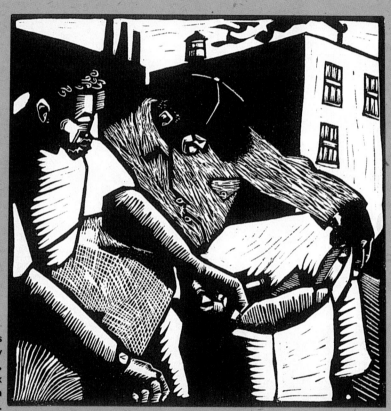

Justin Hawkins
(Brooklyn, New
York), *Two Men*,
12 x 12 in. (30.5 x
30.5 cm), Linoleum
print, 1995.

SIMPLE PRINTMAKING

A BEGINNER'S GUIDE TO MAKING RELIEF PRINTS

with

**LINOLEUM BLOCKS
WOOD BLOCKS
RUBBER STAMPS
FOUND OBJECTS
& MORE**

Gwen Diehn

LARK BOOKS

A Division of Sterling Publishing Co., Inc.

Dedication
FOR J.D.D.

ACKNOWLEDGMENTS

Many, many thanks to Katherine Duncan,
my editor at Lark, who graciously took on this
book when her schedule was already full and
managed to ferry it through sometimes rough
waters with unfailing kindness and good cheer.
Thanks also to Dana Irwin, who designed the
book, made projects, did drawings, and worked
wonders to pull together so many pieces. I owe
much gratitude to Ann Turkle, Sue Simpson,
Bob Hall, Elana Froehlich, and Fran Loges,
who test-drove the manuscript, spending hours
reading the earliest drafts and helping me
clarify instructions as they carved blocks and
made prints. Thanks also to Porge Buck for
moral support as well as for the loan of pieces
of work from her collection. Thanks, too, to the
artists who contributed work for the gallery
pages and projects to the book. Finally, I would
never have been able to write the book without
the help and inspiration of my printmaking
students and colleagues in the art department
at Warren Wilson College. Their questions and
willingness to push limits and take risks have
driven my own development as a printmaker
and as a teacher.

Editor: **Katherine M. Duncan**
Art Director: **Dana M. Irwin**
Photography: **Sandra Stambaugh**
Illustrations: **Gwen Diehn, Orrin Lundgren**
Editorial Assistance: **Heather Smith, Veronika Gunter**
Production Assistance: **Hannes Charen**

Library of Congress Cataloging-in-Publication Data

Available

10 9 8 7 6 5 4 3 2 1

Published by Lark Books, a division of
Sterling Publishing Co., Inc.
387 Park Avenue South, New York, N.Y. 10016

© 2000, Gwen Diehn

Distributed in Canada by Sterling Publishing,
c/o Canadian Manda Group, One Atlantic Ave., Suite 105
Toronto, Ontario, Canada M6K 3E7

Distributed in Australia by Capricorn Link (Australia) Pty Ltd., P.O.
Box 6651, Baulkham Hills, Business Centre
NSW 2153, Australia

The written instructions, photographs, designs, patterns, and projects
in this volume are intended for the personal use of the reader and may
be reproduced for that purpose only. Any other use, especially com-
mercial use, is forbidden under law without written permission of the
copyright holder.

Every effort has been made to ensure that all the information in this
book is accurate. However, due to differing conditions, tools, and indi-
vidual skills, the publisher cannot be responsible for any injuries, loss-
es, and other damages that may result from the use of the information
in this book.

18.21/24.95 *Publishers Quality*

If you have questions or comments about this book, please contact:
Lark Books 19580 12/01
50 College St.
Asheville, NC 28801
(828) 253-0467

Printed in Hong Kong by H&Y Printing Ltd.

ISBN 1-57990-158-1

CONTENTS

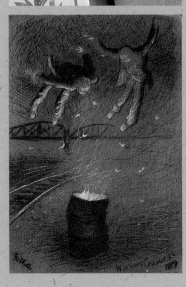

WHEN YOU WERE A FEW MINUTES OLD, YOU MADE YOUR FIRST RELIEF PRINT. Someone inked up your wrinkled little foot and pressed it against the paper of your birth certificate, and there it was: your first mark in the world! All of the elements of relief printing were there: an object with some areas raised in relief to the background (your foot with all its wrinkles and ridges), some ink that was applied to the raised surfaces (the stamp pad that the nurse pressed your foot onto), a means of pressing (the nurse's hand), and a flat surface that received the ink (the birth certificate). Is it any wonder that relief printmaking is the oldest kind of printmaking?

In all printmaking, the artist first prepares a block (also called a plate) so that some areas will hold ink when it is applied and others won't. Block preparation must be such that the block holds ink in the same places each time it is inked. The artist then puts ink on the block or plate by various means, and presses it to a flat material in order to make the print or impression.

What distinguishes one kind of printmaking from another is the means used to keep ink on some parts of the block and off others. In relief printing, ink is kept in place because certain areas of the block are carved away, leaving other areas raised or standing in relief. The printmaker rolls ink onto the block by means of a roller, called a *brayer*, that distributes the ink onto the raised or relief parts of the block. The carved-away parts don't touch the brayer, so they don't get inked.

Porge Buck (Black Mountain, North Carolina), *Nest,* 17½ x 11 inches (44.5 x 27.9 cm), 20th century. Woodcut block. Courtesy of the collection of Lewis and Porge Buck.

Finally, the artist presses the block to a flat material, such as paper, and the ink is offset onto it, producing a reversed image of the design that was carved into the block. Pressing can be done by *burnishing* (or pressing) with various implements including wooden spoons, smooth rounded wooden drawer handles, and specially made burnishing tools (*barens*), or by means of a printing press. The artist then repeats the inking and pressing process for as many prints as he or she wants to make.

Printmakers choose their medium for two main reasons: to make multiples of artwork and because of the kinds of marks they can make using printmaking media. In this book, you will learn about the qualities of relief prints

that make them uniquely suited to different kinds of expression. In the first section of the book, you will learn how to develop ideas and translate your ideas into visual forms. If you have little or no experience in making original art or developing original designs, you might work through all of the suggestions for developing designs. If you are more experienced or confident, you might skim this section and focus on the particular ideas that interest you.

The following section on materials and tools includes detailed information on how to use (and maintain) relief printing materials and tools. If you are inexperienced, this section will provide a good introduction to processes that you will use in the techniques section that comes later in the book. As you grow in familiarity with the processes and tools associated with printmaking, you can use this section for reference when you have specific questions.

The next part of the book begins by telling several different ways to transfer a design onto a block so that you can carve it. Inevitably, printmakers make mistakes, so you'll be given information on making repairs to a block.

Eight techniques are then presented that introduce different ways of working in the medium of relief printmaking. The techniques range from the least complex (printing with found objects) to the more challenging (making multiple block color prints). At the end of the book you'll find several projects in which relief prints are given practical application.

Throughout the book are sidebars that give information about the history and traditions of printmaking, while introducing you to the world of printmaking and its arcane lore. A gallery section which showcases the work of printmakers will give you ideas for prints of your own and stretch your imagination regarding the possibilities of this medium.

The book was designed to be used as a shop manual. I encourage you to make notes, underline, dog-ear the pages, and live with it as you work. Like a good cookbook, it will accrue in value as you add your own notes and experimental results. In that way you can enter into the tradition of printmakers, great experimenters every one.

A brayer (top) is used to roll ink onto a block. A baren (center) is used to burnish the back of the printing paper.

7

Prehistoric Images

The urge to make images is nearly as old as the human race, and the desire to make exact copies of images seems to have developed along with the ability to draw, paint, and carve. Long before the emergence of what we call printmaking, people in different parts of the world experimented with ways of repeating the images they made, in order to communicate as well as decorate.

Some of the first drawings and paintings ever made are found on the walls of the caves at Lascaux and Altamira in the south of France and Spain. Among these drawings are some of the very first "prints"—in the form of handprints. Some were made by smearing paint on someone's hand and pressing it against a flat surface—a forerunner of relief printing. Others were made by smearing the wall with animal fat, placing a hand on top of it flat against the wall, and blowing powdered charcoal through a hollow reed over the surface surrounding the hand. When the hand was removed, the area it had blocked from charcoal created a negative handprint—a forerunner of stencil printing.

Other early prints were made by the ancient Sumerians of Babylonia, who lived around 6,000 years ago in the area now called the Middle East. These people made seals or stamps by carving raised or relief images on the flat ends of clay cylinders. After firing, the seals were hard, and were then used to print the design into soft clay surfaces. These imprinted images served to identify the owner or maker of an object.

The Olmec Indians of ancient Mexico made seals out of tubes of unfired clay that were carved with relief designs on the curved sides rather than the flat ends. Once fired, these cylinder seals were inked with ink made of animal fats and pigments from soils and plant parts. The ink was rolled onto the sides of the cylinders, which were then used to decorate smooth strips of bark or other surfaces with ceremonial designs. Sometimes the designs were applied directly to the human body.

Ceramic pot fragments showing stamped patterns, 15th-16th century A.D.
Berry Site in Burke City, North Carolina; North Carolina Office of State Archaeology

The ancestors of today's Cherokee Indians, who lived in the southeastern United States as long ago as 8000 B.C., used several methods of decorating pottery, all of which involved processes that we now associate with printmaking. One frequently used method was to carve relief designs onto flat wooden paddles, which were then pressed into the sides of unfired clay pots. Another method involved building up a relief surface on a wooden paddle by wrapping the flat end with twine before pressing it into the surface of the clay. Cord was also wrapped around some unfired pots so that it pressed into the soft clay and left an imprint after it was burned away in the firing process. Today, archaeologists find many pot shards bearing these lovely and often intricate patterns. The patterns are so successfully repeated that the designs themselves are a means of identifying the pottery.

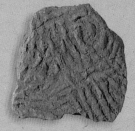
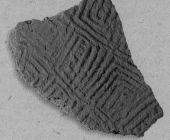

"WHERE DO I START?" YOU ASK. Sometimes just looking at someone else's print is enough—you're excited by its beauty, you know what you want to do yourself, and all you have to do is figure out how to do it. But at other times looking at someone else's work is discouraging. "There is no way I can make a print like that," you moan. "I can't even come up with an idea!"

Even artists with many years' experience face the problem of what to do next. No one can insert ideas into your head, but there are practices that can help you get started. On some days, you may find that it takes very little to set the ideas flying. On others you may need to run through the entire list of start-ups. Just remember two things:

Hare

■ The idea doesn't have to be a vision of the fully realized and finished piece.

Goose

■ The subject of your art is the question—not how you're going to draw or carve the blocks.

An excellent practice is to keep a folder of all the ideas you come up with every time you run through the activities listed here. Sometimes an idea that seems so-so right now will trigger a terrific project in a few months. And sometimes you will find that you have more ideas than you can work on at once. Your ideas file will let you relax, knowing that all your ideas are in one place and that you won't forget any of them. It's interesting how the shifting context of your life brings new experiences and perceptions to bear on your old ideas, so that when you revisit your file, your old ideas may look different and filled with possibilities.

Left: Anonymous 18th century woodblock print

Finding Ideas

1. Sometimes it's easier to think in terms of collections or series, rather than individual pieces. Begin by listing, quickly and without any agonizing at all, as many collections as you can think of. One list might begin this way: flowers blooming in my garden this summer, insects in the garden, letters of the alphabet, positions the cat sleeps in, hand woodworking tools, doorways in Italy. Another might begin like this: shoes, vegetables, sailboats, varieties of lettuce, musical instruments. The great thing about a series, of course, is that you know what you're going to do next, at least for the next few pieces.

9

2. Here's another list-making idea. First, make a list of stories, poems, songs, or favorite sayings. List your favorite folktales, stories your parents told you, sayings that have been important to you, songs that you love to sing out loud. Second, when you have several items on your list, begin to branch out from them to list the visual images that the poems, stories, sayings, and songs bring to mind.

3. This technique is one you can start doing any day, anywhere, and it will bring you pleasure, no matter where you take it next: Carry around a small notebook or sketchbook for a day, and begin to notice what you like to look at. Do you enjoy the way that light enters your bedroom first thing in the morn-

ing? Do you have a favorite corner of a neighborhood garden? Do you love the shapes and colors in the produce section of the grocery store? Jot down these images or ideas in your notebook. Make a pencil or watercolor sketch, not a careful drawing. Many artists make prints in response to what they see, and their prints help others see things in new ways.

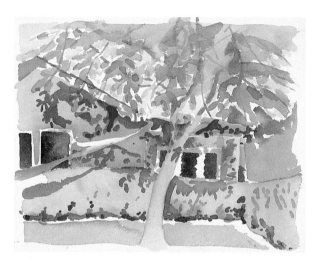

4. This next idea is a two-part list. First, make a list of the ideas and feelings, the beliefs and hopes that most occupy or inspire you. Then begin looking for colors, shapes, textures, places, and objects that evoke one of those feelings or that symbolize one of the ideas. Look at pictures, and also look beyond them—sometimes pure color and shape can express a feeling no picture can; at other times a particular object may be so laden with meaning that it acts as a symbol for your idea.

Many people make art to give visual form to their feelings, beliefs, and ideas. Artist and writer Jules Heller, in his 1972 book *Printmaking Today,* tells about a conversation

10

he had with the noted American printmaker Will Barnett. Barnett told Heller how he came up with the image for his woodcut "Singular Image." He said that he noticed a particular crack in the city sidewalk as he was walking on a hot summer day. He instantly associated the gash in the pavement with the shapes he had been working with for months. The image made him think of a human figure compressed on all sides by subconscious forces.

5. Finally, give yourself a commission. Decide to make holiday cards; tell a friend that you will make birth announcements for her new baby; volunteer to make posters for an event. Now that you've made a commitment from which there is only one graceful way out, begin to collect ideas for the print. Ask yourself what colors, shapes, textures, objects, scenes, people, or animals might best communicate your ideas and feelings. For example, an invitation to a beach party might feature a beaming sun or a collection of brightly striped beach towels. An announcement poster for your town's annual old-time summer festival might show a group of 1890s' people having a picnic in the park. Play around with ideas for a while before committing to any one design. If you can come up with at least three possibilities, the third idea will almost always be stronger than the first one.

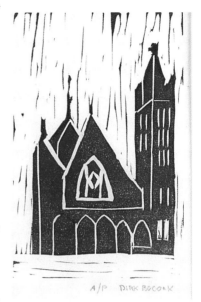

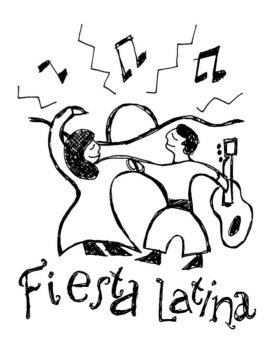

Above:
Dirk Bocook,
Untitled,
Linoleum cut,
5 x 3 inches
(12.5 x 7.5 cm),
1999

Far left:
Justin Hawkins,
Untitled,
Woodcut card,
5 x 3 inches
(12.5 x 7.5 cm),
1999

Left:
Dana Irwin,
Ink sketch for
Fiesta Latina,
Woodcut poster,
3 x 4 inches
(7.5 x 10 cm),
1999

ONCE YOU HAVE SETTLED ON AN IDEA, the question is how to make that idea visible—how to put it into visual form. That's what this section is for. Here, you'll find out how to turn your idea into reality.

Doodles

One useful technique for developing designs is to start paying attention to your doodles—your own visual vocabulary. If you aren't already a doodler, you have ahead of you the simple joys of becoming one. (If you are one already, you

will need no encouragement!) Start by putting some scratch paper and a variety of pens and pencils next to the telephone or bring along your doodling equipment the next time you go to a meeting. Paper napkins, meeting agenda sheets, the backs of envelopes—all of these are fine places to doodle.

Begin collecting your doodles, no matter how

unpromising they seem to you, no matter what they are drawn on. When you have a small collection, look through them and see if you can discern patterns. What kinds of marks do you habitually make? Which symbols crop up often? Which are most pleasing to you? Try reworking some of them. By adding a few lines, you may see plant or human forms emerging. Just this easily, you may be able to turn the doodle into the very design needed for a particular print.

Select a few doodles to develop into designs. Find a photocopier that can enlarge images, and make several enlargements of them, in different sizes. Designs for relief print blocks need lines that are relatively wide, and enlarging your doodles will give you wide lines. If you make copies on transparencies, you can experiment with overlapping and reversing images.

Cut the doodles apart. Now play with grouping the copies. When you arrive at an arrangement that you especially like and that seems to suit the print you want to make, make a couple of photocopies of the design, in the size with which you want to work.

Found Objects

Using found objects to make prints is another good way to slip into relief printmaking. For this exploration you will need only a stamp pad and some paper.

Experiment with stamping small objects that have some flat surfaces—keys, coins, nut halves and washers, pressed leaves and flowers, cut vegetables, seed pods, buttons, variously shaped pieces of uncooked macaroni, commercially baked cookies and crackers, and even your fingers.

Consider making collections or arrangements of prints that reflect a certain place, a particular event, a person, or a relationship. Try printing objects in different arrangements, with repeats and patterns. Later, you will be able to combine these prints with carved blocks or use them on their own.

Another way to use found objects for your design ideas comes after you've stamped them on paper. You can then enlarge your prints with a copier and later transfer the designs to a block for carving.

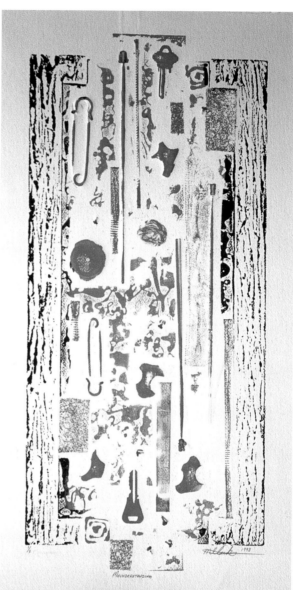

Melissa H. Clark, *Misunderstanding*, Collograph using found objects, 23⅓ x 13 inches (59.7 x 33 cm), 1993

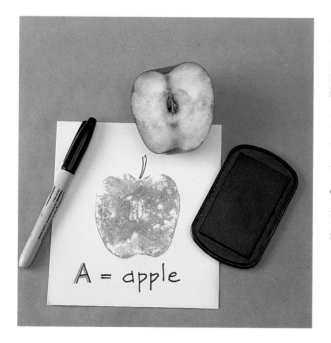

In the example shown (at the left), the artist wanted to make an alphabet book for a child using prints of real objects from the child's environment. She used a variety of objects, from half an apple for "A" to the child's own thumbprint for "T" to a zipper for "Z."

13

Rubbings

Relief printing is a tactile medium. The surface from which you make a print is raised from the background; the act of "pulling" (that is, making) the print from that surface involves burnishing or rubbing. A good approach to coming up with images for your prints is to become aware of the tactile qualities of various places and situations—the textures in your environment. Spending some time collecting textures is a good introduction to relief printmaking, for textured surfaces are in a sense ready-made relief printing blocks.

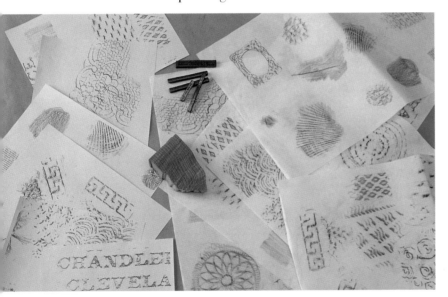

Wherever you go, you will find characteristic textures. An antique shop, the seashore, a city street, your grandmother's attic, your own kitchen—each provides a good starting point. You can gather a good impression of a place by making rubbings of its textures.

To make a rubbing, you will need only some lightweight paper (copier paper or computer paper is fine) and an ordinary crayon or pencil.

When you've chosen your object, lay the paper over the textured area. Secure it with a couple of pieces of masking tape if you think the paper might slip while you are working. Then rub evenly, making wide strokes with the broad side of the pencil point or the side of the crayon. Gradually, as you rub, the texture will reveal itself.

Once you start looking for textures to collect, you will find them everywhere: tree bark, coins, engraved or raised lettering, textured walls, small tiles, window screens, graters, perforated metal, and wood with raised grain. All make excellent rubbings.

Once you have a collection of textures on paper, try enlarging and reducing them on a copier. (Make plenty of copies of each to allow room to experiment.) Cut the rubbings into pieces and rearrange them, combining various textures into abstract shapes, as well as representational ones (shapes that anyone could recognize for what they represent). When you have made an arrangement that you like, tape it together and make a photocopy of it. (You will use this photocopy later to transfer the image to the block for printing.)

Keep the rubbings in a folder. They will be good sources of ideas as you develop other relief print designs.

Lettering

The letters of the alphabet have inspired artists since earliest times. Illuminated or decorated letters in old manuscripts are rich with symbols and embellishment. We still use monograms or designs of our initials on our clothing, and many of us enjoy using monograms on our linens and notepaper, as well.

To find letters and initials for your design, start by looking at letters in a type sample book and calligraphy books. You can find these in your local library. Another source of letters is your computer. Simply go to the font window of your computer and scroll through various font styles until you come to one you like. Type the letters you want, or the whole alphabet, and print them.

Once you have decided on the letters you want to use in your design, enlarge them on a photocopier. Make copies in various sizes, with plenty of copies of each.

You can modify the letters by overlapping them or joining them so that they lock together in a pleasing way. You can add embellishments—leaves, flowers, animals, geometric shapes. If a letter will be printed as the first letter of a page on which you will write part of a story, you might want to design the letter so that it relates to the subject of the text on the page.

In the little book illustrated here, the artist has used an illuminated letter to begin each page. This artist has cut through each letter so that its top half is actually formed by the woodcut design on the next page. This clever device helps the reader turn the pages correctly, since the book is bound on both left and right and it is important to turn the pages in a particular order.

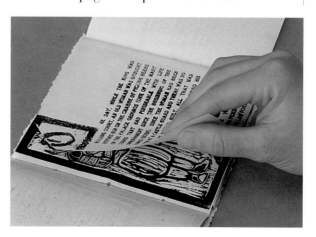

Kathryn Bradley, *The Old King,* **Artist's book with linoleum cuts, 5 x 6 inches (12½ x 15 cm), 1999.** Courtesy Warren Wilson College, Holden Art Center.

In principio creavit Deus cœlum et terram. Terra autem erat inanis et vacua, et tenebræ erant super faciem abyssi: et Spiritus

 L Q H A B E T

Nature Tracings

Artists have incorporated the rhythms and patterns of natural forms into their work in the simplest designs and in the most elaborate—from prehistoric paintings on the walls of the caves at Lascaux to Tiffany's stained-glass windows.

Many natural forms are easy to trace. Pressed leaves and flowers, as well as shells, are good places to start. You'll find some flower shapes better suited to tracing than others (a violet is easier than a rose, for instance). Some flowers will require more internal lines than others to make the shape one that a viewer can recognize.

You can trace some leaves without pressing them, but most flowers need pressing in order to lie flat enough for you to trace them easily. To press leaves and flowers, simply lay them between two paper towels and slip them between the pages of a heavy book overnight.

To do the tracing, you need only paper, a pencil, and the object you want to trace. Lay the object flat on a piece of paper and trace around the outside of it with a pencil. Experiment with tracing the object several times, perhaps overlapping the images, and arrange the shapes in a design or pattern that pleases you. Then modify the outlines as you need to.

When you are finished tracing, remove the objects and draw on the traced images any interior lines or shapes that you want to include. You'll find that it is much easier to draw the curving lines that make a seashell appear rounded when you already have the outline in place. Just notice carefully where on the shell's perimeter each line begins and ends and the curve it makes as it travels across the surface. Add the veins in leaves and the centers of flowers in the same manner.

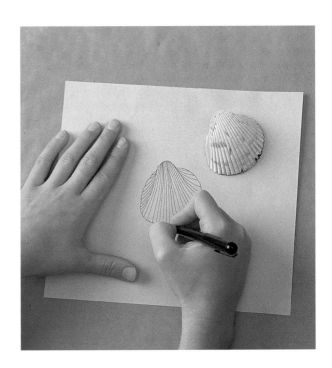

Photographs

Photographs—your own or someone else's—offer a world of design ideas. Taking your own photographs gives the most control over the design, but often photographs taken by other people—including images in magazines and newspapers—can draw your attention to an image and give you exactly the help you need to develop an idea. You may not want to use the entire photograph. Sometimes you will find just a part of the image to transform into a design.

To use a photograph for a design, you will first need to simplify the image. There are at least four ways to do this: direct tracing, enlarging and then tracing, making a collage and tracing it, or simply enlarging the photograph and directly transferring it.

it. Once you've created a tracing that you like, enlarge it on a copier to the size that you need.

A second approach is to use the copier to enlarge the photograph before you trace it. This process offers the advantage of automatically simplifying the photograph: The copier will drop out some tones and darken others, and you can enlarge the image at the same time. The next step is to trace the copy of the photograph, further simplifying the image and perhaps rearranging it.

To directly trace a photograph, trace over the main lines that you want to use. With a marker and tracing paper, trace only the general outlines and larger areas of the image. Keep in mind that you are using the photograph as a reference—you're not trying to make a facsimile of

Upper left: A tracing can be made by hand.

Left: Make a collage of photographs to create a new image.

A third possibility is to make copies of the photographs and then cut up the copies, using some elements from one photograph and other elements from the others. Rearrange the elements to your liking, then paste them into a collage. Trace the collage to simplify it, just as you would a single photograph.

All of these methods require only the photograph, tracing paper, and a marker with a wide tip. Before you start to trace, think of the design as divided into solid or textured areas.

Using a fat marker helps you keep in mind the bold and graphic nature of relief printing. Tracing with a wide tip gives the lines in your print more width than would a fine-line pen. (It is possible to make fairly fine lines in relief printmaking, but these are best carved out of solid areas, rather than left standing in cleared areas.)

The fourth method is the simplest. Make an enlargement of a photograph, and then transfer the part that you want to use to a wood block

using lacquer thinner (see pages 51 and 52). You must use a fairly simple image for this method. The copier will drop out the middle values (grays), leaving only the blacks and darker grays. You will then carve away all the light areas that will be left as white on the paper.

Keep a reference file of photographs from which you might want to work someday. And begin to think about printmaking when you are snapping pictures. For example, if you want to make a series of woodcuts about a vacation cabin you go to, take a roll of pictures that might translate well into woodcuts on your next trip there. Even if you don't yet know what prints you want to make, keep a photograph reference file anyway. Then you'll know where to look when you find yourself one day needing to draw a cat grooming itself or an apple tree in full bloom.

Color Tracings

One way to develop a design with several colors is to begin with a very simple watercolor painting. You will be using three or at most four colors, and working in stages to simplify a scene.

Sit in front of the object or scene you have chosen, and use a viewfinder to frame the picture (see page 21). Your main job here is to simplify what you see, so begin by asking yourself where the darkest areas are, where the lightest areas are, and where the middle values (the in-

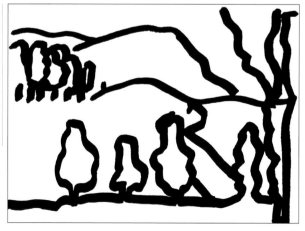

Trace an image with a wide-tipped marker in preparation for transferring it to the block.

DEVELOPING A DESIGN

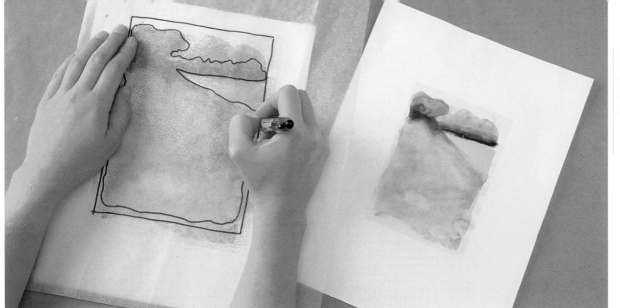

between areas) are. Then assign each area a color—a light one for light areas, medium for middle-value areas, and dark for dark areas. Don't worry about details.

In your own watercolor, paint in the light areas first and progress to the darker areas. In the example shown here, the scene was a golden wheat field surrounded by green fields with dark shadowy woods behind them. The yellow field was painted first as a simple yellow triangle, more or less the shape and relative size that it seemed to be in real life. Next, the green was painted in the general area of the field and also over the lower part of the background. Then gray was painted in the background where the mountains were. When the dark purple was brushed in, the wet purple paint mixed with the wet green paint and made a red-purple color behind the shadow, adding a nice fifth color.

This same watercolor process works well for simplifying a still life, an interior, and even a figure. The important things to remember are

these: Work from the general to the particular, look for colors that seem the right value (lightness or darkness) to you for each area of the scene and for each other, and apply the watercolors from lightest to darkest.

Once the painting is dry, you are ready to trace. You will need one sheet of tracing paper for each color. First trace the outer edges of the entire composition on each sheet. Now lay one of these sheets over the watercolor again, matching the outlines, and trace one color area onto it. Do the same for each of the remaining colors. If you have areas where one color has been painted over another, be sure to include the double-painted area in both tracings.

Later, you will transfer each tracing to a different block, all of the same size, and carve the design. When the blocks are inked with the appropriate color and printed over one another, the resulting print will be similar to your original watercolor.

19

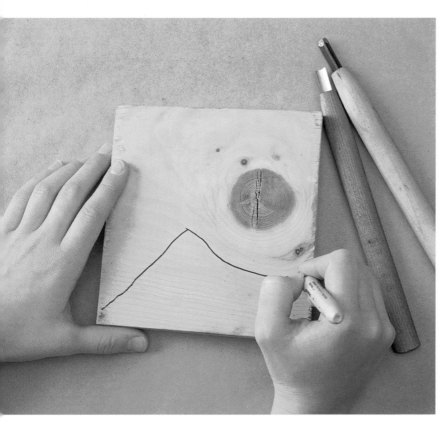

A related technique that can yield fresh and compelling designs is to carve the block directly, with no preliminary drawing or design at all. Of course, this approach requires a lot of practice as well as a willingness to take risks. It is useful to sketch your design idea on paper several times before starting to carve, in order to familiarize yourself with its shapes and lines. Also, take frequent working proofs or rubbings to see how the design is coming along. It also helps to hold the block up to a mirror frequently in order to check the way the design looks when it reverses, as it will do in the print.

With all the risk and challenge of this method, you might wonder why anyone uses it. Once you become comfortable with direct carving, the process of carving feels more like drawing. With practice, you will gain a great deal of control over the character of your lines and over the textures you develop. Eventually, you will be able to respond to the way your carving looks, making changes that relate to what you have done already, rather than simply following a traced design without modification.

Drawing directly on the block with a marker

Finding Designs in Wood

Sometimes the block of wood itself—the movement of the wood grain, the arrangement of knots—will give you an idea for a print. In this case, all you need to do is divide the block into areas suggested by the grain that need to be carved away or textured, and indicate lines of the grain that you want to carve in or leave standing.

When you draw a design directly on the block, it's important to use a medium that will not indent the wood. A ballpoint pen or hard pencil often leaves marks so deep they show up in the finished print. A marker or a piece of chalk or charcoal is a better choice.

Even though you may generally prefer to work with a design drawn on the block, practice in direct cutting will give you the confidence to deviate from your plans when you can see that a slightly different texture or line would do the job better. Direct cutting also allows the kind of process of which the great contemporary Japanese woodcut artist Shiko Munakata has spoken: "The mind goes and the tool walks alone."

Start with a Drawing

For many people, the thought of making a drawing might sound somewhat intimidating. But keep in mind that you need only make a rough drawing to use as a guide. Think of the drawing as simply a map of an object or a scene, a kind of diagram.

Composing the drawing is an essential first step. For example, when you look at your cat sleeping on top of the kitchen table and decide to make a drawing of her, the first thing you must do is to simplify the scene. One way to do that is to make a viewfinder. Cut a small square or rectangle in a piece of light cardboard or stiff paper. Close one eye and hold the viewfinder up to your other eye. The viewfinder lets you frame the scene in various ways. Move the card away from your eye and then closer to it—the scene changes. When you like the way the scene looks, draw a square or rectangle on your sketchpad of the size you want the drawing to be, and begin to map out the scene. Refer to your viewfinder as often as needed. Just draw the major lines and areas; don't worry about details—this is just a map.

Once you have the general shape or area mapped out, put away the viewfinder, and concentrate on making the lines and shapes the right length and the right shape relative to each other. For example, in your drawing of the sleeping cat, check the size of her head. Does the height look right in relation to the width? Does the length of her body look right in relation to her head? Look at your horizontal lines.

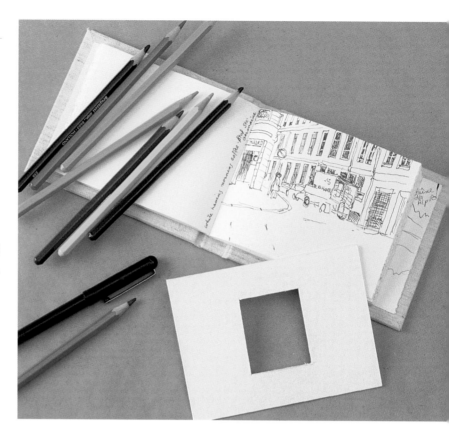

Are they truly horizontal, or should they slant slightly?

Once you have a drawing that you like, proceed as you would with a photograph. Trace the drawing with a fat marker, and enlarge it on a copier. Decide which areas you might want to leave as solid areas, and which areas might look good with textures carved into them. Finally, be sure the lines are wide enough to carve. Since you will carve away the background and leave the lines in some cases, these lines need to be at least ⅛ inch (3 mm) wide to hold up.

Compose a drawing using a simple viewfinder

Some Quick Tips on Drawing

Drawing is basically a matter of selection. You can't possibly draw every detail that you see, so you must select the lines and shapes, textures, and darks and lights that give the essential information about the subject.

An excellent way to improve your drawing is to make a copy of someone else's drawing. Find a simple line drawing that you like, and set out to make as faithful a copy as you can. As you do this, you will begin to understand the choices that the artist has made. Your hand will travel where her hand has traveled. Then, when you draw something from life, you will remember something of this other drawing, and the memory will help you make good choices in your own drawing.

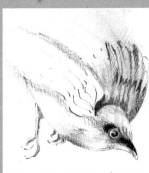

Of course, the only way to become good at drawing is to draw—as often as possible. If you make 20 drawings a day for a month, you will become much better (and much more comfortable) at putting marks on paper in a way that pleases you.

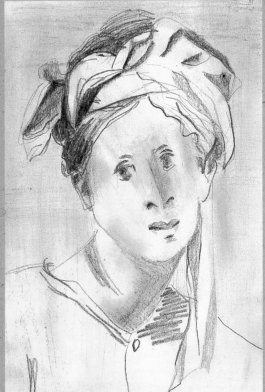

One helpful suggestion: Get a small sketchbook that you can slip into your pocket, and take it with you wherever you go. Fill it with drawings while you wait at a restaurant, while you talk on the telephone, as you wait for a bus, when you see something you don't want to forget. After a while, you will have a great reference file—a rich collection of drawings to use in future prints.

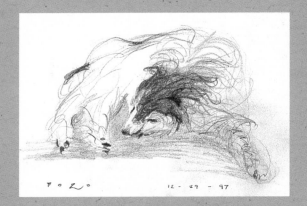

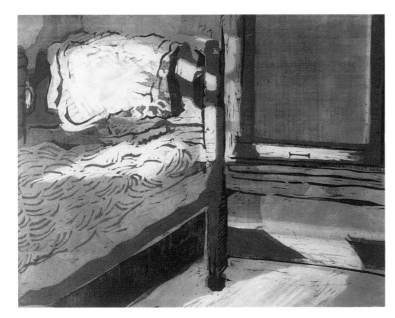

Gwen Diehn, (Swannanoa, North Carolina) *Bedroom Corner,* 15 x 12 in. (37.5 x 30 cm), Woodcut print, 1983.

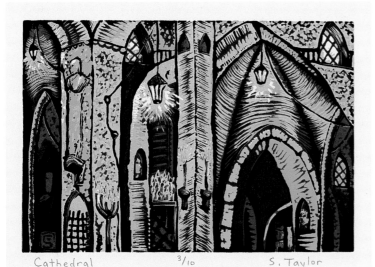

Sylvia Taylor, (Freeville, New York), *Cathedral,* 9 x 6 in. (22.5 x 15 cm), Linoleum multiple block print (ed. 10), 1999.

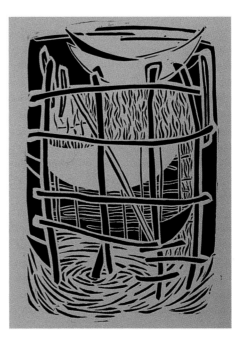

Laura Bentz (Gallup, New Mexico), *Zuni Mountain Suite: Apogee,* 4 x 6 in. (10.2 x 15.2 cm), Linoleum print, 1999.

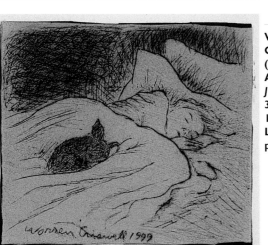

Warren Criswell (Benton, Arkansas), *Janet Sleeping,* 3⅜ x 4 in. (9 x 10.2 cm), Linoleum print, 1999.

Pilgrimage Prints

Look around the room in which you are sitting and notice which objects are dependent on photography for their existence. Now imagine all those things gone—books, magazines, newspapers, the framed reproductions that hang on your walls, printed labels and instructions, the little refrigerator magnets that say "You have a friend in Pennsylvania" and "Jimmy's Front End Alignment." This is the visual environment in which you would find yourself if you lived in Europe in the year 1400. Chances are, the only image in your house, unless you were one of very few wealthy people who could afford an original painting or drawing, would be a small picture of a saint—a souvenir that one of your relatives brought back from a pilgrimage to one of the many holy shrines that dotted the countryside. And that image would be a woodcut.

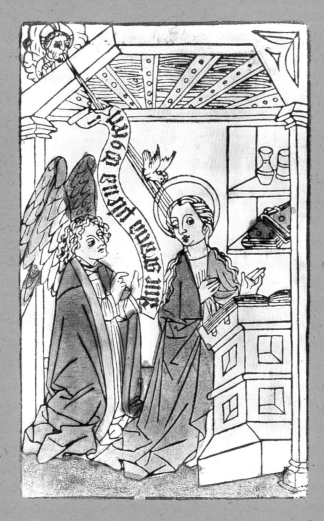

Anonymous, *Annunciation*, German woodcut, 15th century. Photograph and Slide Library, The Metropolitan Museum of Art, New York. Bequest of James Clark McGuire, 1931. (Accession no.: 31.54.118)

The very earliest European prints on paper taken from carved wooden blocks were images of saints or scenes from religious stories, intended to incite piety in the beholder by reminding him or her of the particular saint's life. The designs were crudely cut; there was clearly no intention of making realistic representations. In fact, in many instances the same carving is titled "St. Agnes" on one print and "St. Anne" on another from the same period. Apparently those who carved, printed, and sold the images were interested in putting as many as possible into people's hands, and it was easier to reuse a block than to carve a different one for each shrine. There are some cases in which the bodies of several saints are exactly the same but the heads are different, leading scholars to the conclusion that the images were printed from several interchangeable blocks.

MATERIALS AND TOOLS

A RELIEF PRINT IS MADE BY PRINTING THE RAISED OR RELIEF AREAS OF A BLOCK. The block is prepared by either carving away the background (or non-printing areas), or building up areas that then stand in relief to the background. Relief printing requires simpler tools than any other kind of printmaking. For example, it is perfectly possible to make subtle and sophisticated prints using only a pocketknife and a block of scrap wood. Nevertheless, knowledge of other tools and how to use them will increase the repertoire of marks that you can make, as well as allow you to refine your carving and printing skill.

All of the techniques presented in this book can be done with the tools described below. If your budget is limited, begin by buying a mat knife and a medium-sized gouge for carving; a whetstone and some light machine oil for honing the knife and gouge; a bench hook for keeping your block in place while you carve (you can make one yourself or buy one); a 4-inch (10 cm) brayer for distributing ink on your block; and a flat, wooden spoon for pressing and burnishing. Gradually add other tools as you feel a need for them, and improvise whenever possible.

Printing Blocks

Any flat material, soft enough to carve, and with a surface capable of holding and releasing ink, can be turned into a relief printing block.

The following section covers some of the most commonly used materials for this purpose.

WOOD

Wood is the traditional material for relief carving. Early printmakers sometimes engraved blocks made from the end grain of boxwood or other very hard woods with tools similar to metal engraving tools.

Wood engraving yields extremely fine detail with crisp lines and textures capable of standing up under thousands of impressions. Because the process is slow and difficult, most wood engravings are small.

An engraved block and the image printed from it.

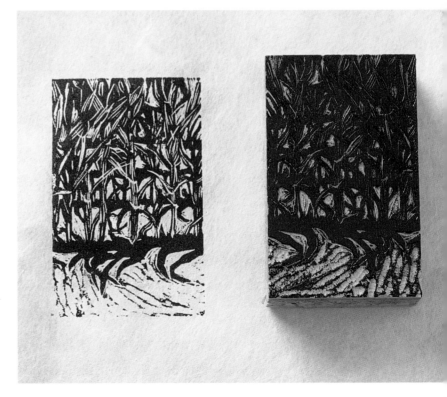

Wood carving, on the other hand, is done on the plank grain of wood with knives, gouges, and chisels. Historically, artists from different traditions have used different kinds of wood for carving. Traditional Japanese woodcuts were done on very hard wood such as cherry. Hardwoods, though more difficult to carve, yield crisp lines and great detail and are able to be printed many times before showing any degradation of carving. Try cherry, apple, pear, mahogany, or oak if you want to use a hardwood block for carving.

Softwoods are easier to carve, but sometimes have a prominent grain and knots that need to be taken into consideration. Softwoods that work well for carving include basswood (which tends to have very smooth grain), white pine or yellow pine (yellow tends to be grainier than white and a little tougher to carve), poplar, redwood (which sometimes crumbles), and willow.

Plywood works well when you need a large block or when you plan to make sawn blocks (see page 81). (Birch plywood has an especially smooth, even grain.) Remember that the texture and grain of the wood can affect the way the block prints, and look for plywood that has a finish that fits your design ideas.

Pine shelving, which consists of many small pieces of wood glued together, makes a very good block for large-scale printing. These blocks are usually easy to carve, free of knots, and hold a line nicely. The seams between the wood pieces won't show in the print.

Scrap wood—pieces of old furniture, orange crates, cigar boxes, driftwood and other weathered wood—can also be used for carving. Sometimes these woods have interesting surface textures that you want to leave intact on the surface; others might need to be sanded before carving. Experiment to see which woods work best for the designs you want to do.

Scrap woods can be used effectively for carving, and often provide interesting textures.

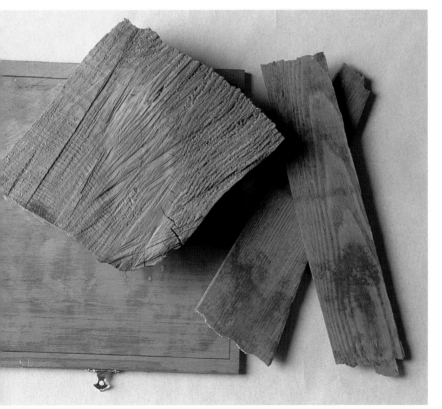

MATERIALS AND TOOLS

Early Woodcuts

The popularity of woodcuts with a religious theme in the Middle Ages was almost matched by that of woodcuts done in the service of amusement. Card gambling was a widespread pastime, and a number of decks of cards survive that have designs printed by woodcut.

From 1400 on, woodcut printing was used to produce commercial goods such as playing cards, greeting cards, and tarot cards. Prints were highly suitable for these purposes because they were easy to make as well as being direct and immediate in communication. The crudeness of the prints, due in part to the roughness of the available paper and the method of inking the block, precludes their being considered adequate reproductions of hand-painted or drawn originals. They were made for common people and were certainly not considered to be fine art. Most early European woodcuts had no shading and were printed in black and white. When color was added, it was added randomly by hand with no attempt to fill printed outlines.

Woodcutters were considered to be carpenters rather than artists, and their activities were regulated by the relatively low status carpenters' guild. Many of these early woodcutters traveled around selling carved kitchen implements, such as butter molds, along with their printed playing cards and other images.

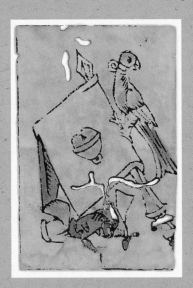
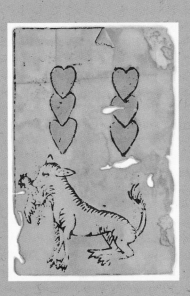
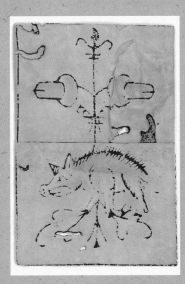

German playing cards, woodcut, 1460.
The United States Playing Card Company Private Collection; Cincinnati, Ohio

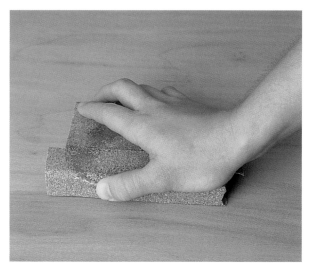

When lumber is milled, shallow grooves called milling marks are created that run perpendicular to the grain of the wood. Even though these milling marks are almost invisible to your eye, they'll show up plainly after you ink the block and print it. So, the first step in every wood block carving project is to sand away the milling marks with a sanding block.

You can easily make a sanding block out of a scrap of 2 x 4 or any wood that measures around 5 x 3 x 2 inches (12.5 x 7.5 x 5 cm). Cut a piece of sandpaper wide enough to wrap around the wood. Staple the sandpaper to the wood where the paper overlaps, or simply grip the overlap of the sandpaper as you sand with the flat surface. Always sand in the direction of the grain. To see if milling marks have disappeared, hold the wood flat at eye level and sight along the surface. You shouldn't be able to see any small grooves running perpendicular to the grain if you've sanded sufficiently.

Linoleum is a composition material made of linseed oil, rosin, and particles of cork pressed together. You can buy it unmounted or mounted for carving. You can readily buy type-high (0.9186 inch [2.2 cm]) linoleum blocks at art supply stores. If you can't find the exact size that you need, it is easy to saw linoleum blocks with a hand or power saw. Unmounted sheets of linoleum come in larger sizes and are cheaper than linoleum blocks. You can carve it as is, or glue it to a piece of ½- or 1-inch (1.3 or 2.5 cm) plywood with wood glue. Linoleum blocks are capable of producing crisp, clear prints, and the blocks hold up under a large number of impressions.

Linoleum is quick and easy to carve with either linoleum-carving tools or regular wood-carving tools (see pages 32-38). Because it has no grain, you can easily make cuts that curve gracefully in any direction. Since linoleum dulls tools rather quickly, keep sharpening stones nearby while carving or replacement

blades on hand. If linoleum is stored in a cold place, it tends to chip and can be difficult to carve. To solve this problem, put the block in a sunny spot for a few minutes to warm it up.

Linoleum can be repaired to some extent with wood putty. The acetone in most putty will degrade the surface of the linoleum, so care must be taken to keep putty off places that do not have to be filled. Filled spots must be lightly sanded when they are completely dry.

To transfer a design to linoleum, use graphite or carbon paper. Acetone transfers will not work because acetone degrades the surface of linoleum.

ERASERS AND SOFT RUBBER SHEETS

Ordinary rubber or plastic erasers make good materials for carving small, simple blocks. You

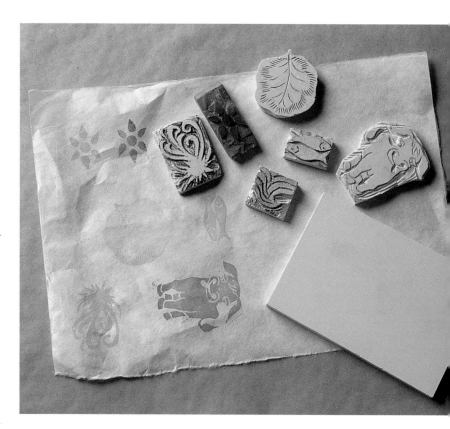

can also buy flat sheets of soft rubber in art supply stores made for the purpose of carving. Experiment with both to find out which best suits your design and style of working.

Erasers are easy to carve with linoleum or wood-carving tools and mat knives (see pages 32-38). Draw the design directly on the block using a pencil, or transfer it by means of a graphite rubbing (see page 53). Eraser material does not allow fine lines or great detail, so designs need to be kept relatively simple and bold. Print small blocks with rubber-stamp pads or press them into thin layers of printing ink that have been rolled out onto an ink slab.

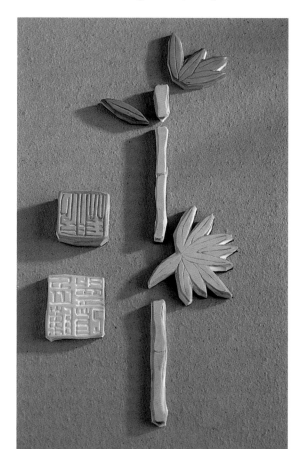

Bottom left and top right: Carve rubber erasers or sheets to make simple blocks for printing.

29

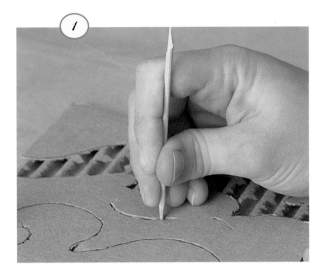

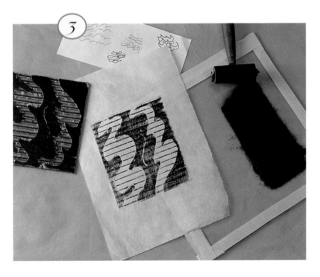

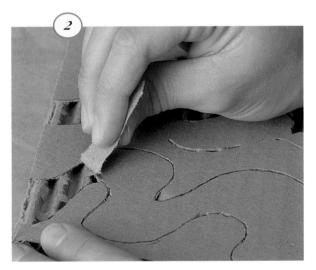

CARDBOARD

Ordinary corrugated cardboard can be used to make very simple printing blocks and produce interesting textures. Begin by drawing the lines you want to cut onto a piece of cardboard, then trace the lines with a mat knife by cutting through the top layer of paper on the cardboard. Widen the channel of each line by drawing a toothpick along it (photo 1). Create textures by outlining the textural area with a knife before peeling away the top layer of paper to expose the corrugations (photo 2). Waterproof the cardboard by painting it with acrylic varnish to prepare it for inking. After the varnish dries, use a generous amount of ink to coat the cardboard. Apply light pressure to print it—too much pressure will flatten the cardboard (photo 3).

UNUSUAL AND ECCENTRIC MATERIALS

Any flat material that can be carved that will hold and transfer a thin layer of ink can be used for making relief prints. Some possibilities include tempered and untempered pressed fiberboards as well as vinyl tiles and other floor tiles. Each of these materials has its own advantages as well as limitations. Experiment with them to discover which materials you prefer.

You can use all sorts of found objects and everyday items for printing (essentially, anything that can be inked up and pressed onto another surface!). For example, printmaker Antonio Frasconi made several intriguing

books a number of years ago using alphabet noodles, cookies, and crackers as printing plates. Carve or cut vegetables to expose their natural patterns, and use them as the basis of designs for prints as well as for adding textures and patterns.

ADDITIVE MATERIALS

Materials such as rubber inner tubes, computer mouse pads, and plastic place mats can be used to build up relief areas on a block instead of carving away the surrounding areas. Simple shapes that stand out cleanly from the background can be cut out quickly and easily with scissors and glued to the surface of the block to make bold designs. (A collograph is made in this way.)

Art supply stores carry a self-adhesive, flexible plate made especially for this purpose. The material can be carved once it has been cut up and adhered to a block. It is very soft and easy to carve, yet holds a fine line nicely.

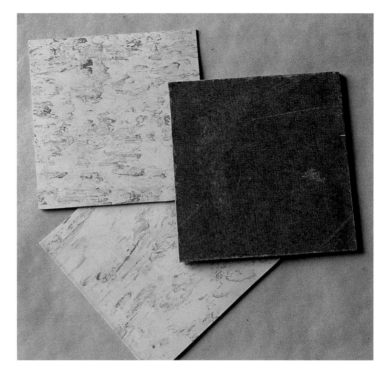

Top right:
Materials that you might consider for printmaking include vinyl tiles and pressed fiberboard.

Bottom right:
Build up the relief portion of a block with additive materials such as computer mouse pads and plastic place mats.

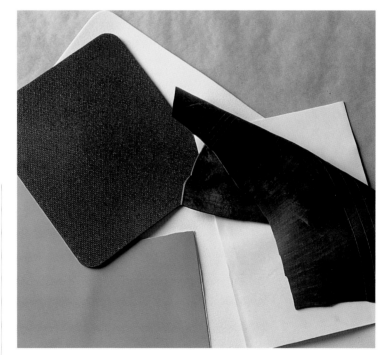

31

**Left to right:
Japanese knife,
small gouge,
medium
gouge, large
veiner, small
veiner, chisel,
mat knife**

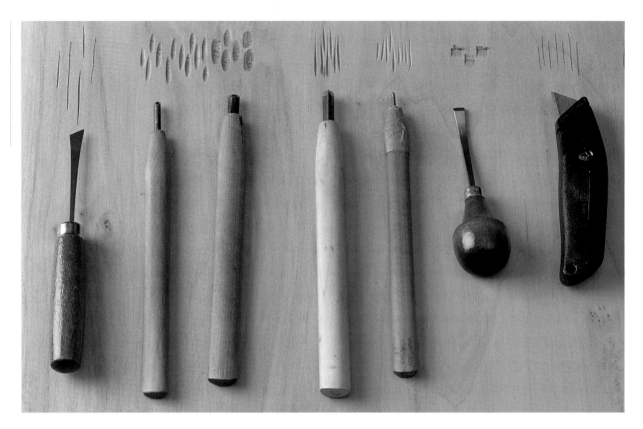

Carving Tools

The following section covers tools that have
been adapted or developed by printmakers for
carving a design on a block.

KNIVES

Knives are the pencils of carving—essential
tools of relief carving that are used to outline
relief areas and to make lines. Two kinds of
knives are used by most woodcutters: a
Japanese knife and a mat or razor knife. Make
sure that any knife you choose feels comfort-
able in your hand before you buy it. Always
pull the knife toward yourself when carving.

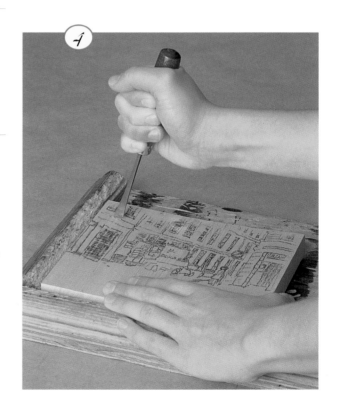

The Japanese knife has a relatively small, sharply pointed blade that is ground to a bevel. A good Japanese knife can be sharpened easily and holds an edge well—an advantage that it has over a mat or razor knife. Art supply stores that sell woodcut tools carry Japanese knives, and most sets of woodcut tools contain one.

To hold a Japanese knife in the traditional fashion, hold it in two hands with your dominant hand gripping the handle, and your thumb resting on top. Wrap two fingers of the other hand around the handle near the blade to help guide the motion as you pull it toward your body. To hold it with one hand, clench it firmly in your fist, and pull it as it makes its cut (photo 4). To make delicate cuts, hold it in your hand like a pencil.

A mat knife fitted with a heavy-duty blade will perform the same function as a Japanese knife, but you'll need to replace the blade as it dulls. You can hold it like a Japanese knife and pull it toward you; or, in the more usual western fashion, grip it like a tennis racquet (photo 5). You can also hold it like a pencil, especially if you're making delicate cuts or making the first cut in outlining a shape (photo 6).

When using a knife, it is necessary to make two slanted cuts that form a channel for every line that you cut. If the knife is held nearly upright, the channel and the line will be narrow. If the knife is held at a greater angle, the channel and line will be wider.

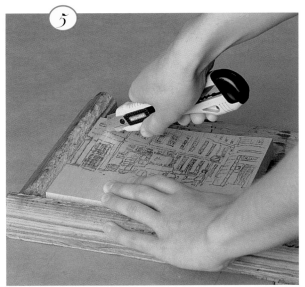

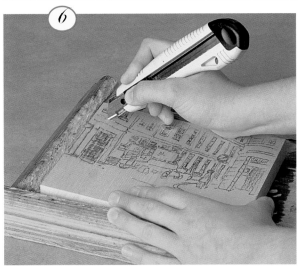

GOUGES

If a knife is the pencil of carving, a *gouge* is the brush. The blade of a gouge is ground so that it is semi-circular in cross section. Gouges come in a wide variety, ranging from round ones (used mainly to cut wide lines and clear small areas) to shallow, almost flat ones (used to clear large areas).

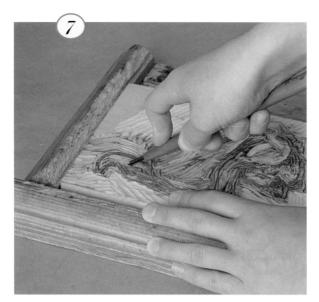

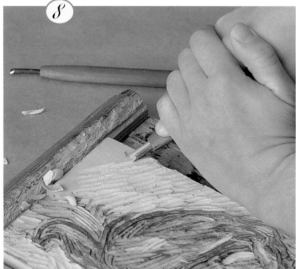

sible, aim the tool away from design areas that you don't want cut into by accident.

VEINERS

A *veiner* (or V-tool) has a V-shaped blade. It is quicker than a knife for cutting lines and outlining because it cuts both sides of a channel at once. Veiners range in size and, therefore, create a range of line widths. Handle it as you would a gouge.

CHISELS

A *chisel* is a tool with a flat, beveled tip that can be useful for clearing large areas of a block and for removing wood at the base of an outline cut made by a knife (photo 9). Some people prefer to use a wide, shallow gouge for these jobs; others find chisels handy.

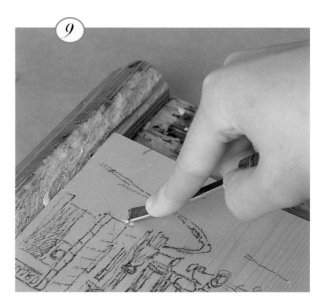

Push the gouge away from your body when you use it. Hold it in one hand to make small cuts (photo 7). Hold it in two hands to make larger, deeper cuts or cuts in tough wood. When gouges are used to clear areas of wood, they cut most easily in a direction diagonal to the grain (photo 8). Since it isn't always possible to cut diagonally, take extra care when cutting in the direction of the grain to avoid splitting the wood along the grain. As often as pos-

MALLETS

If you use a chisel, you may find a mallet helpful for moving the chisel through particularly tough areas of the plate. A hard rubber or wooden mallet is easier on the handle of a chisel than a hammer would be. Be very careful when using a mallet; slips are easy to make which might cut away a part of the block that you don't want to lose. As often as possible, aim the tool away from areas of relief that you want to leave on the plate.

SHARPENING STONES

Sharpening stones or *whetstones* are essential for maintaining the blades of carving tools. A dull blade is not only inefficient and frustrating to use, it can also be dangerous, since it can skip and skid out of control unpredictably. To keep your tools in good hone, you'll ideally need three whetstones in different degrees of hardness and light machine oil such as sewing machine oil. You'll also need a *slip stone*—a small whetstone that is shaped to slide inside a gouge or veiner against the unsharpened surface. You can buy whetstones from some hardware stores or art supply stores. Slip stones are sometimes sold with sets of woodcut tools or through printmaking supply companies.

Before sharpening your tools, touch them carefully with your fingertip or brush them against a fingernail to determine their sharpness. You can also hold the tool up to a bright window and sight along the edge. Any glints of light along the bevel of the blade indicate spots that are dull.

To sharpen a knife, begin with a coarse whetstone, such as a carborundum. Put a few drops of oil on the stone to float away the tiny pieces of metal that are worn off the blade during honing. Place the bevel of the knife flat against the stone, and rub the blade in a gentle circular motion. Tip the blade so that the bevel stays in perfect contact with the stone. After a few minutes, turn the knife over and repeat this process before wiping away the oil. Now use a medium

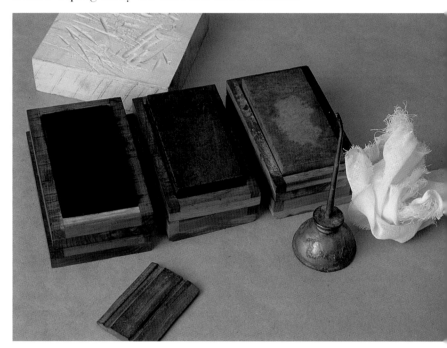

stone, such as a Washita, to sharpen the knife more. Follow up with the hardest stone, such as a black Arkansas. To finish the job, grip the knife in your fist, and pull the blade firmly against the grain of a piece of scrap wood. You'll remove any remaining *burr*, or tiny pieces of metal raised by the honing. Test the knife by carving on a piece of wood or linoleum. While you're carving, you may need to stop at times to bring the knife back to hone with the hardest stone.

Keep your carving tools in good hone with three whetstones in different degrees of hardness and light machine oil.

Sharpening gouges and veiners takes more skill, but you'll get plenty of practice as you carve and will soon be very good at honing these tools. To sharpen these tools, use sharpening stones in the same sequence as you would for sharpening a knife.

To sharpen a gouge, hold its bevel against the stone and rock your wrist from side to side as you move the blade in circles to maintain contact with the stone (photo 10). Under no circumstances should you change the bevel of the blade while sharpening it—even though it may seem like patting your head and rubbing your stomach at the same time! Once you've sharpened the outside of the gouge, use a slip stone to remove the burr that has been raised on the inside of the blade (photo 11). Remove any remaining burr by gripping the tool like a dagger and pulling it toward you against the grain of a piece of scrap wood (photo 12). Test the tool by carving into some scrap wood or linoleum.

To sharpen a veiner, begin by honing each of the outside edges exactly as though you were sharpening a knife. The point at which the two outside angles meet should be sharpened like a gouge. To do this, fit the tiny bevel to the stones, and rotate your wrist slightly as you rub it in circles. Then use a pointed slip stone to remove the burr from the inside of the blade. Test the veiner for sharpness as you would a gouge.

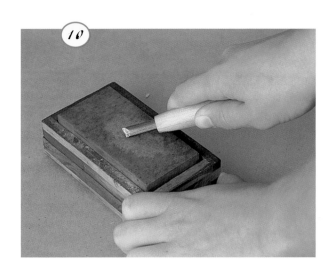

Albrecht Dürer

German artist Albrecht Dürer (1471-1528) was the first master artist known to choose the woodcut as a medium for artistic expression, rather than as a means of reproducing images made in another medium.

Around 1486, Dürer began making woodcuts as a wood carver's apprentice in Nuremberg. His early works were book illustrations, and even in these early years of his career he was known for his lively touch in carving.

Dürer broke with tradition by drawing his own designs on the block and cutting most of the block himself, thereby ensuring that his blocks reflected not only his ideas but also his artistic handwriting. He used very hard fruitwoods such as apple, pear, and cherry to obtain fine detail and lines that would hold up under hundreds of impressions.

From 1490 to 1494, he traveled to different cities in Germany, earning his living as an illustrator while absorbing different influences and ideas that led to further development of his art. Around 1495, Dürer seems to have broken from the book form, as he began producing larger woodcuts that stand on their own as complete works, no longer bound by the limitations of a text.

One outstanding Dürer print is his *Rhinoceros* from 1515. The detail that he was able to realize on a small scale, using a medium that is not generally chosen for its ability to render fine lines, is nothing short of amazing.

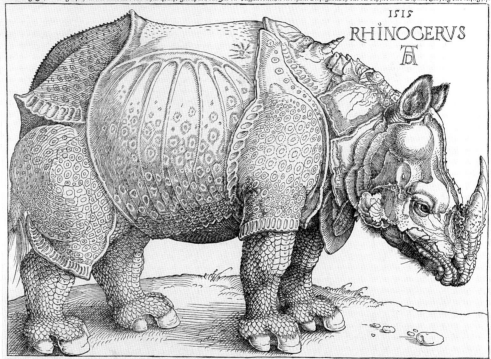

Albrecht Dürer, German, 1471-1528, *The Rhinoceros*, 1515 Woodcut on white laid paper, 9⁷⁄₁₆ x 12 inches (240 x 304 mm), Cooper-Hewitt, National Design Museum, Smithsonian Institution/Art Resource, New York. Gift of Leo Wallerstein 1950.5.24

LINOLEUM-CUTTING TOOLS

Often the first set of carving tools that anyone buys is an inexpensive set that includes a single handle for holding several interchangeable metal blades. These sets usually contain blades for a Japanese-style knife, two sizes of gouges, and two sizes of veiners. They work well for carving linoleum, erasers, and rubber sheets, but they aren't well suited for carving wood. If you use them, keep an extra set of blades on hand so that you can change the blade as soon as it begins to grab or skid. Use these tools as described previously under the sections on knives, gouges, and veiners.

BENCH HOOK

When carving a block, you'll need a device to hold the block still and provide sufficient resistance while you work with gouges, veiners, or chisels. (This is especially true when both of your hands are involved in manipulating the tool.) A bench hook is easy to make and does the job admirably.

You can make a simple bench hook out of three pieces of wood nailed together (photo 13, fig. 1) or make the deluxe model with a series of notches (photo 14) to provide options for angling the block in directions other than north and east. Metal bench hooks are available at art supply stores that sell printmaking supplies.

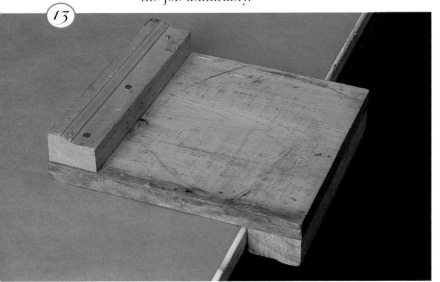

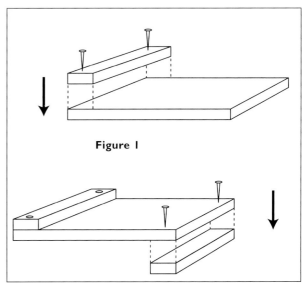

Figure 1

CLAMPS

You can also use C-clamps to fasten the carving block to a table or workbench. Use them to fasten the block firmly to the table for deep carving or for clearing large areas. Sandwich a scrap of linoleum or heavy cardboard between the wood and the clamp to avoid bruising the wood or linoleum (photo 15).

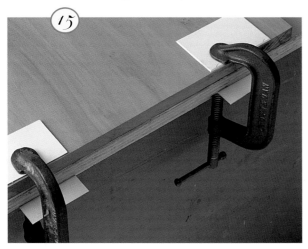

Flexible plates, such as unmounted linoleum, can't be held in place with a bench hook. Instead, place a piece of inexpensive rubber shelf liner cut to about 12 x 15 inches (30 x 37.5 cm) underneath the block (photo 16). This rubber mat is also a good place to rest tools when you're not using them.

Printing
Materials and Tools

Once you've carved the block, you'll be ready to ink it and print. The following section describes the things you'll need to know about this process.

PAPER

When you become a printmaker, you enter into a world of paper in which considerations such as opacity, texture, surface finish, and pH neutrality become extremely important. Relief prints can (and have been) printed on almost every kind of paper, but there are a few things to consider when choosing paper for your print.

First of all, if you spend the time to carve a block and make original prints, always buy acid-free or pH neutral paper. This paper will last a long time and look as good in a few years as it did on the day you bought it.

A selection of printmaking papers.

Very cheap papers, such as newsprint and construction paper, fade and deteriorate very quickly and are not worth using for any print. If cost is a consideration, buy less expensive acid-free drawing paper, and cut it down to the size you need.

Second, textured paper or paper with inlaid flowers and other plant parts will affect the way a block prints, so buy paper with a smooth finish unless you want a particular texture to show up in your print.

Visit an art supply store to see the range of papers available. Ask to see Japanese papers, such as hosho, kinwashi, goyu, and mulberry. Papers are such a pleasure to use and can add so much to the look as well as the life of your print that it is important to be aware of the range of possibilities and choose thoughtfully.

Ideally, paper should be stored flat, but this is often impractical. If you don't have the space to do this, roll up the sheets. Machine-made paper has grain, and the best way to roll paper is with the grain. To determine the direction of

the grain, lay a piece of paper flat on a table-top, and bend it (without creasing it) onto itself in one direction. Gently press the bend with your hand to test its springiness. Bend it the opposite way, and test it again. The grain runs parallel to the bend that is the softest and easiest to press. Now roll the paper parallel to the grain.

To keep the roll bound, make a strap from scrap paper that measures approximately 2 x 15 inches (5 x 37.5 cm). Close it with a small piece of tape (photo 17). Never put tape directly on your printing paper.

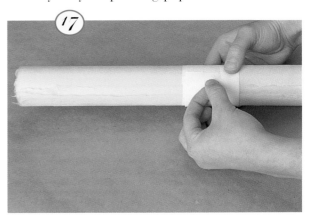

During printing, protect paper from accidental ink smudges by handling it with small folded clips of scrap paper (photo 18). When burnishing delicate paper, always protect it with a sheet of clean scrap paper between the print and the brayer. When stacking prints, even if they seem to be dry, interleave them with sheets of clean scrap paper to prevent ink from offsetting onto the back of the next sheet.

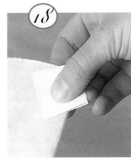

Right: Untextured paper will produce a textured print.

Prints on Paper

The first people to think of printing on paper were the Chinese, who, incidentally, were also the first people to make true paper. Paper was invented, according to legend, in A.D. 105. The combination of this invention with the older tradition of relief carving made possible the easy and inexpensive reproduction of images and text, which was as revolutionary in those days as the computer has been in our time.

The Chinese used printing on paper as a vehicle for spreading the teaching of Buddhism in the form of standard texts called sutras. Because paper deteriorates rapidly, we don't know exactly when the first Chinese prints on paper were made. The oldest existing example is the 17-foot long *Diamond Sutra,* printed in A.D. 868, and discovered in 1907 in the walled up Cave of the Thousand Buddhas in Western China.

Scholars who have analyzed early Chinese woodcuts tell us that text and images were carved on one block of wood. The block was then painted with a water-based ink, and the paper was pressed against the block and rubbed to pick up the impression.

The *Diamond Sutra's* design is anything but primitive. It is clear from its confident, sophisticated imagery and style of calligraphy that it was done years after many similar, preceding works. (Prints on paper deteriorate from weather, insects, and sunlight as well as acids in the paper, and we can assume that the first relief prints on paper are long gone.) We can also assume that the *Diamond Sutra,* safe from the elements in its cave, is a representative of a long tradition that began sometime after A.D. 107.

Diamond Sutra, Chinese, A.D. 868, Woodcut, 9¾ x 11½ in. (24.2 x 29.2 cm), length of scroll 18 ft. (5.5 m), By Permission of the British Library (OR 8210, folio 2)

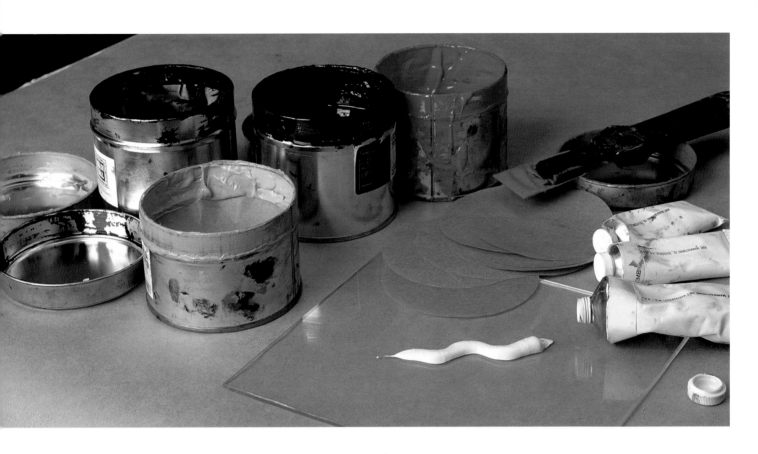

INKS

Relief prints are printed with either water-based or oil-based inks. Traditional Japanese woodcut printing uses water-based ink mixed with rice paste that is brushed onto the block. In the West, water-based inks are used primarily in schools because they are much easier to clean up, although professional printmakers use them when they want the particular look that they impart. Many western printmakers prefer the intensity and luminosity of oil-based inks printed in thin, delicate layers.

You can buy either type of ink in small tubes or 16-ounce (448 g) cans. A good starter palette for inks includes black, magenta or alizarin crimson, cyan or phthalo blue, process yellow or lemon yellow, white, and a couple of earth colors (raw or burnt sienna or umber and yellow ochre). Some manufacturers sell what are called "process colors" in magenta, cyan, yellow, and black. These are very intense, transparent colors designed for mixing.

A lot has been written about color mixing, and to develop subtlety in this process requires time and experimentation. A couple of guidelines can help you get started. First, always begin with the lighter of two colors and very gradually add the darker hue (photo 19). Second, lower the brightness or intensity of a color by adding a small amount of its complement, or the color opposite it on the color wheel. You can mix lovely grays by mixing pairs of complementary colors together.

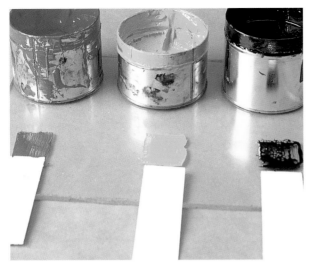

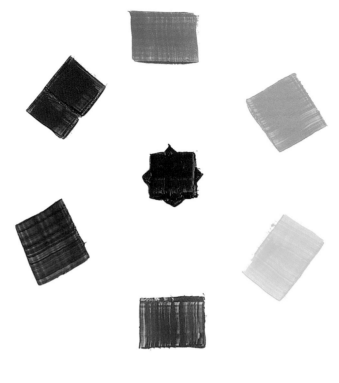

To alter the opacity of inks, you can mix them with certain ink additives. Oil-based ink can be made semi-transparent by mixing in a small amount of transparent base. Water-based ink can be made semi-transparent by mixing in a small amount of reducer. (Be sure that the ink additive you use is compatible with the kind of ink you're using.) Although these ink additives will change the intensity of the colors slightly, they make it possible to layer inks in interesting ways.

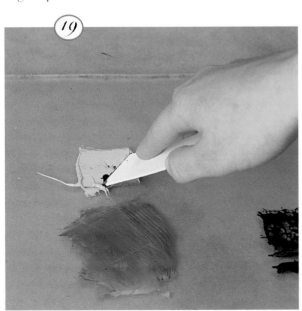

Far left: Intense colors designed for mixing, or "process colors"

Top left: Complementary colors

Bottom left: Complementary colors combined to make grays

43

Top right: Small rectangles of cardboard, putty knives, or spatulas are useful for cleaning up ink.

Bottom right: Brayers are used to apply ink on a block.

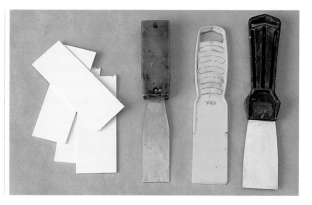

SPATULAS AND SKIN PAPERS

A small spatula, putty knife, or rectangle of light cardboard is useful for removing ink from cans and for scraping during clean up. When you're finished using a can of ink, remove the excess ink from the rim and coat it with petroleum jelly to prevent the lid from becoming permanently fused to the can.

If using canned inks, you should also buy or make a supply of skin papers—circles of wax paper cut to fit exactly over the smoothed surface of the ink in order to keep it from forming a hard, unusable skin. Skin papers must be removed completely and replaced with new ones each time the cans are opened to keep the air away from the surface of the ink.

BRAYERS

Rollers made of rubber or composition materials that are used to apply ink on a block are called *brayers*. They are available in various hardnesses and lengths. A brayer of medium hardness is better for inking relief plates than a hard brayer because it is more forgiving of irregularities. Start out with a 4-inch (10 cm) medi-

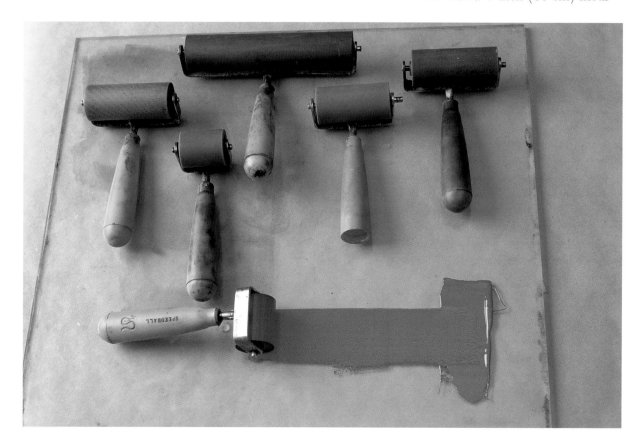

um roller; then add 6-inch (15 cm) and 2-inch (5 cm) rollers later. Avoid storing brayers by laying them on a flat surface, because, over time, the roller can become flattened. Ideally, you should hang them by screw eyes attached to their handle ends, or rest them so that the roller portion isn't touching the shelf or counter.

To ink a plate, begin by using the brayer to roll out an even film of ink on a perfectly clean, non-porous, flat surface or ink slab (see below). Lightly charge (load) the brayer with ink, then roll it across the block several times in order to distribute it evenly. Don't interrupt the rolling, or a line will result. Always finish a stroke by rolling the brayer completely off the block (photo 20). Check for even distribution of ink by holding the block at eye level to see if all areas are completely covered with a thin film of ink. Carefully remove any small pieces of dust or other material that might have fallen on the inked areas.

to be scraped clean with a razor blade. A piece of tempered glass that measures 12 x 24 inches (30 x 60 cm) is ideal for this purpose. Protect your fingers from cuts by buying a piece of glass with sandblasted edges, or by applying masking tape to the edges.

If you don't want to invest in a glass ink tray, a scrap of smooth-surfaced laminated plastic or a piece of acrylic sheeting will work, but these materials scratch easily and can't be scraped clean with a razor blade. If you're in a pinch, you can roll out ink on heavy glossy magazine pages, and throw them away as you use them. Improvise when looking for an ink tray, but keep in mind the requirements outlined above.

BARENS AND OTHER BURNISHING TOOLS

For printing without a press, you'll need a way to press paper (or burnish it) against the inked

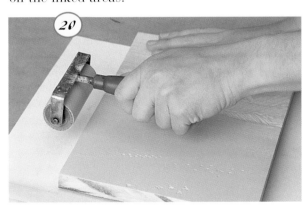

INK SLAB OR TRAY

You'll need a perfectly flat, smooth surface large enough to accommodate your largest brayer to serve as an ink slab for rolling out ink. It should be non-porous and hard enough

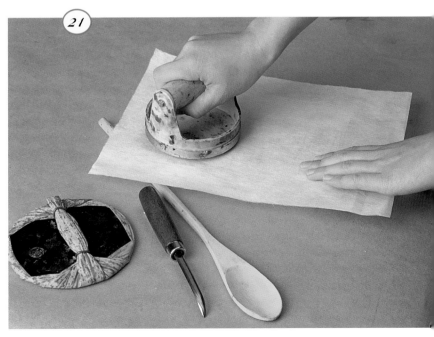

block (photo 21). A Japanese baren is a tool made of rolled rope and bamboo and designed to apply variable pressure to the back of the paper that has been placed over the inked block. Other versions of this tool made of plastic and synthetic materials work well, but not quite as sensitively as a Japanese baren.

You can also use a wooden spoon with a shallow bowl or a smooth, round, wooden drawer pull for burnishing the back of the paper. It's always a good idea to sandwich a piece of clean, smooth-surfaced paper (such as newsprint or inexpensive white drawing paper) between the baren and the printing paper.

SUPPLIES AND TOOLS FOR CLEANUP

The first rule of a painless cleanup is to scrape and wipe first before adding solvents. For this purpose, become well-acquainted with a razor scraper—a small, inexpensive tool that consists of a single-edged razor blade in a handle. This can be bought at a home supply store or hardware store. This tool removes ink so cleanly from a glass tray that it requires only a quick wipe with a rag to finish the job. If your ink tray is made of plastic or another easy-to-scratch surface, substitute a putty knife for the razor scraper, but don't expect the same miraculous results!

Clean up water-based inks from the ink tray with a razor scraper or putty knife, water, and clean rags. Clean water-based inks from any kind of block by wiping it with a damp rag until the ink is gone. (Some coloration will usually remain even when the ink is cleaned off.) Avoid immersing a woodblock in water since the grain may rise and the block's design could become degraded. To clean brayers, wash them in warm water before drying them off.

Oil-based inks print smoothly with beautiful intensity and luminosity, but they can be such a mess to clean up that many people avoid them because they're unwilling to invest the amount of time needed to clean up after them. Never fear! Substitute vegetable oil for smelly and toxic solvents such as paint thinners, and you'll be able to clean up oil-based inks almost as easily as water-based inks.

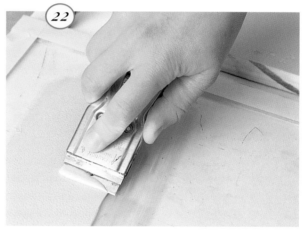

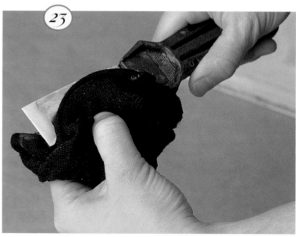

MATERIALS AND TOOLS

To clean up oil-based inks with vegetable oil, first clear away all extraneous items such as ink tubes and cans, scrap paper, and tools. Then scrape the ink tray with a razor scraper or putty knife until it is almost perfectly clean (photo 22). Wipe any spatulas and the scraper with a rag until they're clean (photo 23). Roll the brayer back and forth over old newspapers to remove as much ink as possible (photo 24). Next, pour about a tablespoon (15 mL) of vegetable oil, the cheapest kind you can find at a grocery store, onto the ink tray. Roll the brayer back and forth on the tray to loosen any bits of ink left on it. Roll the brayer on more old newspapers to remove the diluted ink (photo

25). When it seems to be as clean as it's going to get without more help, use an oily rag to wipe the surface, sides, handle, and bracket of the brayer. Keep wiping until the rag comes away from the brayer clean (photo 26). Use an oily rag to finish cleaning up any residue on the tray (photo 27). There is no need to wash anything once it has been cleaned with oil. And your hands, although smelling like a salad, will be nicely soft and comfortable.

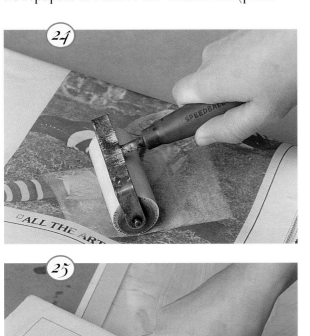

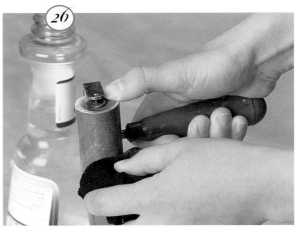

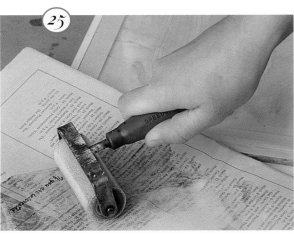

47

Presses

Although a press is not necessary for printing a relief block, there are some cases in which printing is a great deal easier if done on a press. Producing an edition, or a series of the same print, is easier if a press does the burnishing. Large prints or prints with large areas of solid color are also more easily printed on a press.

Relief printing can be done on an etching press, such as might be found in the art studio of a local college or university art department or a community art center. If you find such as press, you may be allowed to use it in off hours. Make certain that you get complete operating instructions from the person in charge of the studio before using the press.

If you keep your eyes open, you may find an affordable, used press to buy. An old proof press left over from the days of letterpress printing makes a fine relief printing press. They are small presses and reasonably easy to move. Printing companies sometimes have old proof presses that they're no longer using and are happy to either give them away or sell them for a modest price.

If you're lucky enough to locate a proof press, you'll need to clean it up by wiping it down with mineral spirits followed by lightweight machine oil. Put gear oil in any oil holes that you find. The press will have a flat bed that moves back and forth under a cylinder. Most cylinders are covered with a piece of waxed lightweight cardboard called pressboard that cushions the paper and equalizes the pressure between the press and the type. Under the pressboard may be other pieces of paper or a thin rubber mat used to increase the padding of the surface. The wood or linoleum surfaces that you will be printing are not as easily damaged as lead type, but will still need some light padding. If the padding on your press is worn, you can replace it with sheets of light cardboard or paper. If you are unable to attach padding to the cylinder, just use a few layers of paper over the printing paper, and leave the cylinder bare.

The block and printing paper should roll under the cylinder just tightly enough to make an impression but not so tightly as to damage the block or the paper. Neither the bed of the press nor the cylinder can be raised or lowered, so you'll need to build up the bed with pieces of matboard or hard cardboard until the fit is right. First put down padding on the bed, then the inked block with the inked surface facing up. Lay the paper over the inked block, gently pressing it with your palm to adhere the paper. Don't shift the paper once you've laid it down. Lay a sheet or two of clean

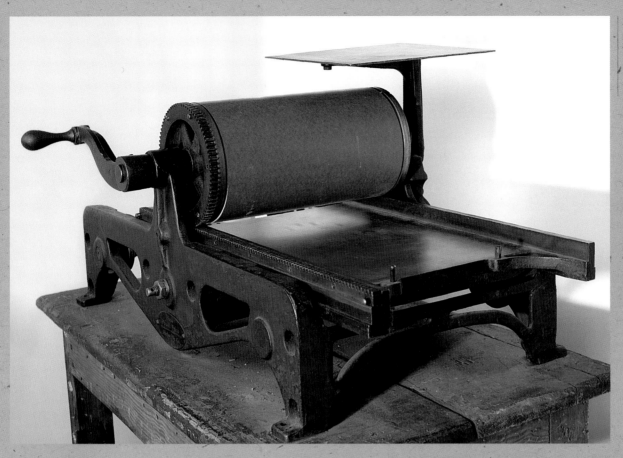

paper over the printing paper to protect it from the
cylinder, or to protect the pressboard from any ink
that might bleed through the printing paper under
the pressure of the press. Crank the block and paper
through the press. Then carefully peel off cover paper
and the print.

If you find that the print is unevenly printed, check
first to make sure the printing block is level on the
bed. (If it is severely warped, you'll have to burnish
the print by hand.) Then make certain that any pack-
ing under the block is level and that the pressboard
paper is smooth and free of creases. If the print still
prints unevenly, try increasing the pressure slightly by

adding a few sheets of paper under the block. If one
area of the block keeps printing light, print a proof of
the print, and cut out the light area from it. Align this
section on the back of the block directly *under* the
portion of the block from which it was printed, and
glue it into place. The additional thickness that you
have added to the block will usually level the block so
that it prints evenly.

TECHNIQUES

THERE ARE A NUMBER OF TECHNIQUES that can be used in preparing a block for printing, and they are presented in this section. Combining these techniques can yield exciting results. The more you experiment, the more you will discover. For example, you may find that the print of a simple found object from a stamp pad may be exactly what is needed to enliven a space in a larger print pulled from a carved block. As you experiment, combine, change, and discover new materials, you'll be taking your place in the long tradition of print-making.

Clearing away portions of the block with a gouge

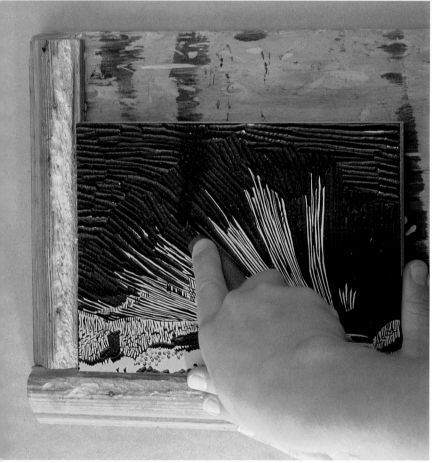

A Note about Proofs and Editions

Printmakers often print *editions*, or a limited number of copies of a print. The artist begins by pulling *proofs* (making trial prints) until he or she is satisfied with a particular one. This proof, called the *artist's proof*, becomes the standard for judging the rest of the edition. All of the prints in the edition, whether five or 50, must match the artist's proof. To be considered prints from the same edition, all must be printed in the same colors on the same kind of paper. Each print is signed and numbered to reflect the total number of prints in the edition and its number in the sequence. For example, a print numbered 5/15 would be the fifth print pulled in an edition of 15.

Prints are always signed in graphite pencil beneath the image. Most artists sign their names, the title of the print (if it is titled), the edition number, and the year the print was made.

Sometimes printmakers prefer to make one-of-a-kind prints called *monoprints*—prints that are printed only once. Sometimes a mono-print is made by printing blocks in repeat. At other times, several colors of ink are painted on the block rather than one color at a time being rolled on with a brayer. A monoprint is a print that cannot be duplicated, and it is not a part of an edition.

Transferring a Design to the Block

AFTER YOU'VE CREATED A DESIGN THAT YOU WANT TO PRINT, you'll need to transfer the drawing or design to the block before you begin cutting. The following section describes various transfer methods.

PHOTOCOPY TRANSFER FOR WOOD

This is a very efficient and accurate way to transfer a design onto wood, especially if the design is complicated. (This method won't work on composition materials such as linoleum.) Photocopy transfer reverses the design on the block, so that the printed design will appear in its original form.

MATERIALS AND TOOLS

Photocopy of design

Woodblock

Sanding block

Lacquer thinner (toluol compound)

Rag

Flat, wide, soft brush

Masking tape

Baren or other burnishing tool

PROCESS

1. Undertake this process in a well-ventilated room or outdoors. Laquer thinner is hazardous and shouldn't be inhaled.

2. Prepare the woodblock by sanding it to remove any irregularities or grease spots from the surface. Position the photocopy facedown on the block.

3. Transfer the design by one of two methods:

Method #1

Wet part of a rag with lacquer thinner, and quickly sweep it over a section of the back of the photocopy (photo 1). Move the rag around, adding more lacquer thinner as needed. (The paper will become transparent when it is wet, so you can see where you have worked.)

As you work, carefully lift and look underneath the paper to check the progress of the transfer. If the design has not transferred completely, add more lacquer thinner and/or more pressure. Be careful not to shift the paper. When you're satisfied with the transfer, remove the tape and the paper. The block is ready to carve.

Method #2

Correctly position the photocopy print side down on the block. Place masking tape across the top edge to serve as a hinge if needed.

Once it's secured, lift the photocopy up, and flip it away from the wood. Use the wide brush to brush the surface of the wood with a strip of lacquer thinner. Quickly flip the photocopy back into place, and burnish the back of the paper in the area of the lacquer thinner (photo 2). Lift to see if the design has transferred successfully. If it has, proceed to the next section of the block. (If it hasn't, apply more lacquer thinner and burnish again, perhaps with more pressure.) Be careful not to shift the paper during this process.

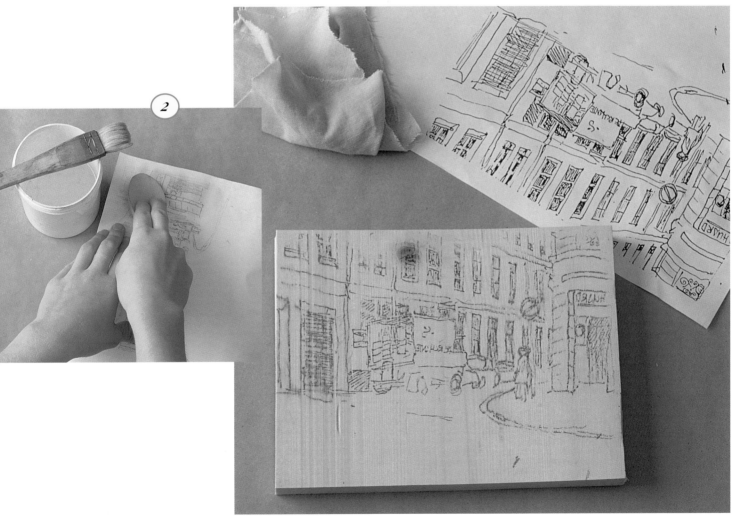

CHARCOAL OR GRAPHITE TRANSFER

This is a simple method involving no hazardous materials. It can be used on composition materials, such as linoleum, as well as cardboard and wood. The disadvantages of this method are that details are sometimes lost in the transfer process, and the design is rather fragile and easily smudged. It can be redrawn with a marker to clarify and fix the design, but to do so takes extra time.

MATERIALS AND TOOLS

Design

Carving block of linoleum, cardboard, or wood

Sanding block (if using woodblock)

Soft graphite pencil (4B or 6B) or compressed charcoal

Baren, flat wooden spoon, or other burnishing tool

Fine-tipped marker

PROCESS

1. Prepare woodblocks by lightly sanding to remove irregularities or grease spots. Be sure that linoleum blocks are clean and dry.

2. Trace over the lines of the design using a soft graphite pencil (4B or 6B) or compressed charcoal.

3. Lay the design facedown on the block. Hold it carefully in place. Use a flat wooden spoon or printmaker's baren to burnish the entire surface of the paper. Check the quality of the transfer by lifting one corner of the paper at a time. Be careful not to shift the paper during the process.

4. When the design is sufficiently transferred, remove the paper. The design will be rather light and can be easily smudged. To fix the design, trace over it with a marker.

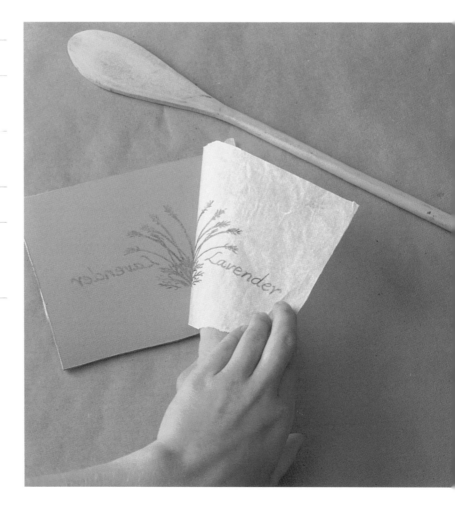

TRANSFER PAPER

A time-honored way of transferring designs to a carving block is by means of transfer paper. This method works for woodblocks, cardboard, and composition materials such as linoleum. Use ordinary carbon paper from an office supply store or colored transfer paper from an art supply store. (You can also make your own transfer paper by completely covering one side of a piece of ordinary drawing paper with either soft graphite or conte crayon.)

MATERIALS AND TOOLS

Design

Woodblock, cardboard plate, or block made of composition materials

Sanding block (if using a woodblock)

Tracing paper (optional)

Carbon paper, transfer paper, or drawing paper covered in soft graphite or conté crayon

Pencil

Fine-tipped marker (optional)

PROCESS

1. If using a woodblock, sand it lightly to remove irregularities and grease spots. If using a block made of linoleum or composition materials, make sure the block is clean and dry. Check to see if your design will work well in reverse by holding it up to a mirror. If not, use tracing paper and a pencil to trace the design so that you can reverse it when you transfer it to the block.

2. Lay the coated side of the transfer paper facedown on the block. Place your design on top of it. (If you've traced the image onto tracing paper for the purpose of reversing the design, lay the traced image facedown on top of the transfer paper.) If the design is large or complicated, use masking tape to attach the tops of the transfer paper and the design to the block so they won't shift.

3. Use a pencil to trace over the design. Press hard enough to transfer the design, but lightly enough to avoid making grooves in the block if using cardboard or wood. Check the transfer of the image by lifting one corner of the paper at a time. Draw over areas that haven't transferred sufficiently. When the entire design has been traced, remove both papers. Depending on the coating material on the transfer paper as well as on the size and complexity of the design, you may want to redraw the design using a marker so that the design won't smudge as you work.

WET PROOF TRANSFER

This is a useful method for transferring a key block design to the other blocks when you are making a multi-colored print with several blocks that needs exact registration (see pages 70-75 for multiple block instructions). This method automatically reverses the design.

MATERIALS AND TOOLS

Design

Printing blocks cut to exactly the same size

Sanding block (if using a woodblock)

Water-based inks

Glycerin (available from a pharmacy or craft supply store)

Ink slab

Brayer

Piece of relatively hard, non-absorbent paper (such as photocopy paper or white bristol drawing paper) cut to the exact size as the first block

Baren, flat wooden spoon, or other burnishing tool

PROCESS

1. If using wood blocks, sand them first.

2. Completely carve the first block. Ink it heavily with water-based ink to which you have added a few drops of glycerin to slightly retard drying. Working very quickly, pull a proof on the non-absorbent paper. Immediately lay the wet proof onto the second block, being careful to place it in registration. Burnish the back of the print to cause the wet ink to offset onto the second block.

3. When you remove the proof, the design will be reversed onto the second block in exactly the right place on the block (see photo above). If several color blocks are needed for the print, repeat the process until you have transferred the design onto each of the blocks.

Repairs

Sooner or later you are going to need to know how to put back a part of a block that you shouldn't have carved away. There are several ways of making repairs, depending on the material you're carving.

Wood is the easiest material to repair. If you accidentally carve away a piece of the block that should be left standing, retrieve the piece and glue it back on with carpenter's glue (photo 1). If the piece is long gone, your only resort is to fill the hole with wood filler or putty (photo 2).

If the mistake is in the middle of an uncarved area, simply fill the hole with a small amount of wood filler or putty. Overfill it slightly. When the filler is completely dry, sand it down so that it is level with the rest of the block.

If the mistake is on the outside of an area that stands in relief, wedge a blob of putty onto the mistakenly carved-away section. Make sure that the blob is slightly larger than you need. After the filler is completely dry, sand it level with the rest of the block. Use wood-carving tools to further shape it.

Linoleum is trickier to repair, but not entirely impossible. As with wood, if you still have the mistakenly carved-away piece, glue it back on with carpenter's glue. The acetone in most putty will degrade the surface of a linoleum block, so if you use putty to repair linoleum,

you must keep it off adjacent surfaces. Fill holes carefully with wood filler or putty before sanding them level. Protect the adjacent surface of the block from the sanding paper. You can also repair linoleum with acrylic modeling paste, but it takes longer to dry than putty.

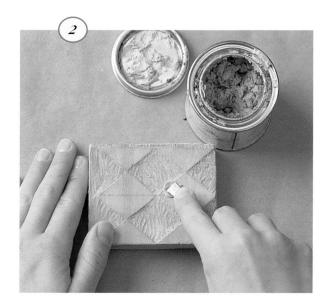

Herbals

If you want to know the values of a culture, notice the images that it makes and reproduces. The proliferation of books on medicinal herbs, known as herbals, in Europe during the late 15th and 16th centuries tells us that health was a major concern of these people. Botanical drawings were produced in manuscripts as early as the first century B.C., but these handwritten and painted manuscripts were rare and precious documents never seen by common people. It was not until the 15th century that we begin to find attempts to reproduce drawings of plants using woodcuts.

The first woodcut herbals were very simple and crude and served more as reminders of plants already known than as accurate descriptions of plants. The first two botanical woodcuts that we know of date from 1475, and were included in an herbal called *Puch de Natur* by Konrad von Megenberg and published in Germany. Another early herbal was that of Apuleius Plotonicus, published in Rome around 1481 by Johann Philippus de Lignamine, the physician to Pope Sixtus IV.

In 1530 the German Otto Brunfels, the town physician of Bern and an amateur botanist, published the first of his three-volume *Herbarium Vivae Eicones*. What distinguishes Brunfels's herbal from earlier ones is that his illustrations were what he called "living portraits of plants." These were plants drawn from nature by Hans Weiditz, whom Brunfels had hired to draw and cut the blocks. Weiditz's woodcuts are delicate and lively, and make good use of the woodcut's ability to show texture and sinuous line. The artist shows every plant in realistic detail with no attempt to idealize. If a leaf is drooping, Weiditz lets it droop. If a bug has eaten a hole in a leaf, Weiditz shows the hole. This inclusion of imperfections makes Brunfels's herbal all the more believable as information. Weiditz's woodcuts are as detailed as drawings, with a great variety of lines and textures. They are so exquisitely done that they have sometimes been falsely attributed to the great German master of the woodcut, Albrecht Dürer.

corum, TOMVS Primus. 21

Plantago Rubea.

Rot Wegerich.
DE PLANTAGINE
Rhapfodia Prima.

Hans Weiditz (active 1518-1536), Illustration from Brunfels's *Herbarium Vivae*, 1530, Woodcut, The Metropolitan Museum of Art, Gift of Mortimer L. Schiff, 1918 (18.57.6)

Printing with Found Objects

You can print from any object with a flat surface on it that will hold ink. Print with odds and ends from your garage, with natural materials such as leaves, or with raw vegetables and fruits that have been sliced and blotted with a paper towel.

The key to success in printing with found objects is lots of experimentation. Spend time test-printing objects to see which ones make marks that you like, and which suit the idea or feeling you're working to communicate.

MATERIALS AND TOOLS

Objects of your choice from which to print

Old pillowcase

Printing paper

Rubber-stamp pads, printing inks (oil- or water-based), or pigment brush pads (available at craft supply stores) in a variety of colors

Ink slab and putty knife (if using inks)

Brayer

Sheets of scrap paper cut to around 4 inches (10 cm) square each

Vegetable oil for clean up (if using oil-based inks)

Rag

1. Begin by folding the pillowcase in half and placing it on the work surface. Lay a sheet of printing paper on top of the pillowcase (photo 1). The slight padding of the pillowcase will help compensate for any irregularities in the surface of hard objects and will insure more complete transfer of ink from the object to the paper.

2. There are ways to ink and print flat objects without getting ink all over the paper and your hands. You're in luck if the object has a natural handle-like part or surface that you can grab in order to avoid touching the stamp pad. Press the object firmly onto the pad and then onto the paper (photo 2).

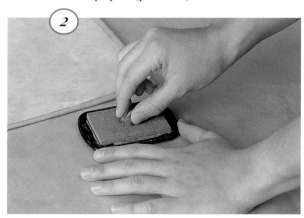

If the object is flat and has no handle-like part, lay it directly on the stamp pad, and place a piece of scrap paper over it so that you can press it without getting your hands inky. After pressing it all over, remove the paper and carefully peel the object up. Lay it on the paper, and place another piece of scrap paper over it to prevent transferring ink from your hands when you press or burnish the object onto the paper (photo 3). If the object is too large for the pad, or if you are using pigment brush pads, pat the pad all over the surface (photo 4). Print it as described above.

If you're using inks instead of pads, place a small amount of ink on the ink slab, and smooth it out with the brayer. Press the object into the ink, and stamp it on the printing paper. As the ink becomes textured from use, roll the brayer over the surface to smooth it out (photo 5).

3. Create the design by printing a series of objects over the surface of the paper (photo 6).

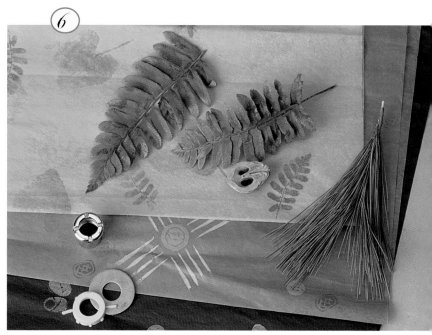

Distressed Block

Sometimes the natural patterns in a piece of wood suggests a design. Look for weathered wood or any wood with a prominent grain and knots. Use tools to distress, or mar, the surface of this wood block to add marks and texture to the print. You can use this technique alone as an exploration of textures, or in combination with another printmaking technique.

MATERIALS AND TOOLS

Piece of soft wood with interesting lines and textures

Sanding block with medium sandpaper

Objects to pound, scratch, or gouge the surface (such as rasps, screwdrivers, punches, nails, screws, or saw blades)

Wire brush

Hammer

Printing paper

Oil- or water-based ink

Brayer

Ink slab and putty knife

Baren or other burnishing tool

Vegetable oil for clean up (if using oil-based ink)

Rags

Razor scraper

Old newspapers

1. Cut the wood to the size that you want for the print, or leave it uncut it has unique irregular edges and an interesting shape. Sand it with the medium sandpaper to remove milling marks.

2. By distressing a woodblock, you can create designs that have large textural areas and no detail or fine lines. You can also transfer a simple design to the block before working, and combine this technique with traditional carving.

3. Experiment on a piece of scrap wood with the tools that you've gathered to find out the kinds of marks that each tool makes (photo 1). Combine various marks to make textural areas that you like. Begin distressing the woodblock by stamping, pounding, scratching, or gouging the surface with a variety of tools. You may choose to use the natural patterns of the wood to guide you.

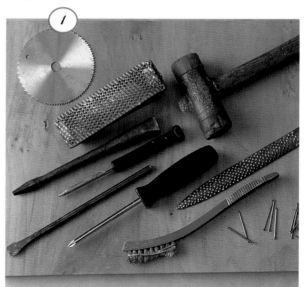

4. If you want to enhance the grain to make it print more clearly, rub the wood vigorously with a wire brush in the direction of the grain (photo 2). When you're satisfied with the design, hold the block up to a mirror so you can see how it will look when it reverses in

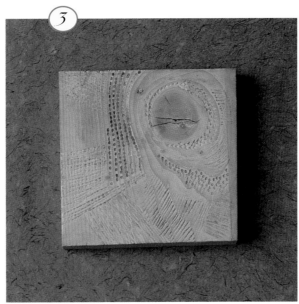

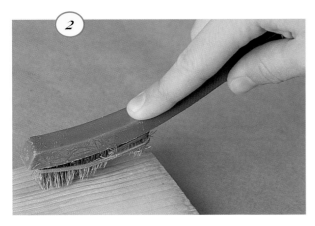

printing. A mirror check will often tell you where you need to add texture or enlarge a distressed area to balance the design. Take trial prints or proofs as you work to guide you. When you are satisfied with the block, brush all loose pieces of wood from the surface, or blow it with a hair dryer to clean it thoroughly.

5. To print the block, begin by clearing an area of the work surface. Tear or cut printing paper and leave at least a 2-inch (5 cm) margin around the image on all sides (photo 3). (You need to leave room to sign the print if you plan to mat and frame it.) Leave too generous of a margin before you leave one that is too narrow.

6. Squeeze or scoop out about an inch (2.5 cm) of ink onto the inking tray or slab. Roll it with the brayer until it is a thin, even

film the width of the brayer and about 6 inches (15 cm) long (photo 4). Don't use all the ink at once; use just enough to cover the brayer completely. When the brayer is covered with a smooth, even coat of ink, roll it back and forth on the block to form a thin, even coat (photo 5, on next page). Pick up more ink with the brayer, and roll it out on the inking tray as you need it. Keep aiming for thin, even coverage of the block. Too much ink will fill in fine

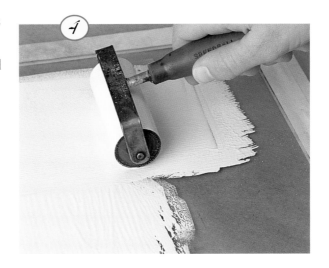

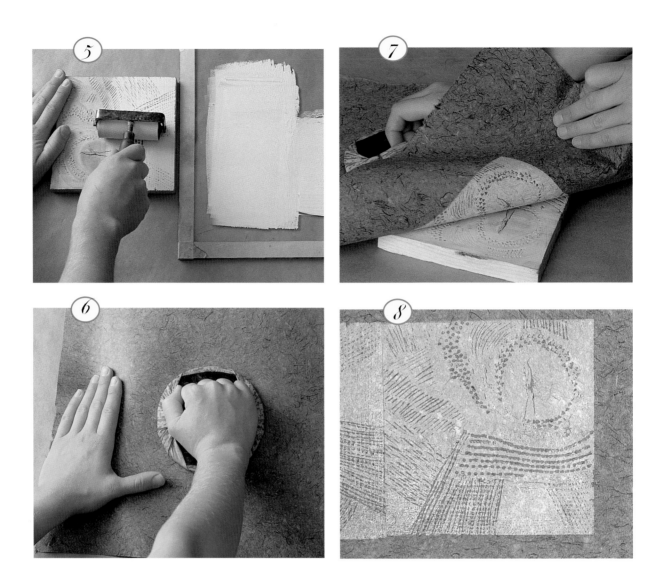

lines and result in a mottled print, while too little will result in thin or blank places on the print.

7. When the ink coverage appears even, carefully lay a sheet of paper over the block. You cannot reposition the paper, so be sure to place the paper where you want it the first time. Gently press the paper to the block with your hand. Use a baren, wooden spoon, or some other burnishing tool to apply even pressure over the entire surface of the block to transfer the ink (photo 6). Hold the paper in place, and lift one corner at a time to check your progress (photo 7).

8. When the impression looks complete, peel the print off (photo 8). Place it on a flat surface, pin it to a bulletin board, or hang it from an indoor clothesline to dry. If you have used water-based ink, the print will dry within the hour. If you have used oil-based ink, it may need up to several days to dry, depending on the humidity, temperature, amount of ink used, and absorbency of the paper.

Negative Carving

Negative carving is a technique in which the design is formed by lines and shapes carved out of the background of the block. In other

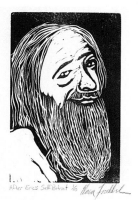

words, the image is composed of lines and spaces shaped by the spaces missing from the inked background. It is a useful technique for designs that have fine lines, because it is easier to carve away a line than to leave a line standing. Use this technique alone or in combination with others.

MATERIALS AND TOOLS

Design and materials for transferring it to the woodblock (see pages 51-55)

Linoleum block or woodblock (preferably fine, even-grained woods such as white pine, poplar, or basswood) cut to the size of the design

Sanding block (if using a woodblock)

Putty or wood filler

Bench hook

Linoleum- or wood-carving tools

Sharpening stones, oil, and a rag (if using wood-carving tools)

Ink slab

Putty knife

Oil- or water-based inks

Vegetable oil and rags for clean up (if using oil-based inks)

Brayer

Printing paper

Scrap paper

Baren or other burnishing tool

PROCESS

1. Saw the block to exactly the shape and size needed to enclose the design. Since the background and edges of the print are prominent in a negative print, be sure that the edges of the block are cut clean and straight. If there are any chips out of the edges of the block as a result of sawing, fill them with wood putty, and allow to dry before going on to the next step.

2. If you're using a woodblock, sand to remove any milling marks.

3. Transfer the design to the block with an appropriate method.

4. Sharpen the carving tools with the sharpening stones, and keep the stones nearby to use as you work.

5. Place the block in a bench hook.

A negative carving is formed by lines and shapes carved out of the background of the block.

Elana Froehlich, *After Eric's Self-Portrait,* 4 x 6 in. (10 x 15 cm), Linocut, 1999.

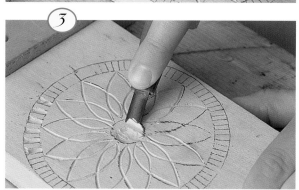

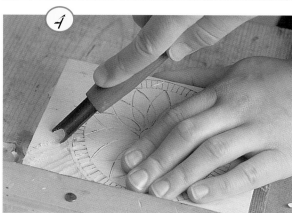

6. Use a knife or veiner to carve the lines of the design and to outline the areas to be carved away (photo 1). Then add texture using a gouge, veiner, or non-traditional tool to areas that need it (photo 2)). Finally, remove the outlined areas with a gouge. These areas will appear in the print as white or the color of the paper (photo 3).

To clear large areas, use the largest, shallowest gouge that you have. (If you're carving wood, carve diagonally to the grain as often as possible [photo 4].) Always aim the tool away from any part of the block that you don't want to carve away.

7. Ink the block with the brayer. Place the printing paper on the block, and then place scrap paper on top of it. Use closely aligned strokes and firm, even pressure to burnish the paper and achieve an even impression of the design. (Pay special attention to large, uncarved areas of solid ink.) Check the progress of the printing by holding the paper in place with one hand and carefully lifting one corner at a time (photo 5).

Positive Carving

THE POSITIVE METHOD OF CARVING leaves the lines and areas that carry the image standing in relief. This technique works best for designs with bold lines and simple shapes. Non-printing areas of the block (those that have been carved out) will often carry marks left by the tools called tool marks. These marks enliven the print with the kind of texture that is associated with this medium. Positive carving is often combined with negative carving in the same design.

MATERIALS AND TOOLS

Materials for transferring design to block (see pages 51-55)

Linoleum or woodblock cut to exactly the size of the design

Sanding block (if using woodblock)

Bench hook

Linoleum- or wood-carving tools

Sharpening stones, oil, and rag (if using wood-carving tools)

Tools for making textural marks (such as rasps, nails, or screws)

Ink slab

Oil- or water-based inks

Vegetable oil and rags for cleanup (if using oil-based inks)

Brayer

Printing paper

Scrap paper

Baren or other burnishing tool

PROCESS

1. If you're using wood-carving tools, sharpen the tools, and keep the stones nearby for resharpening as you're carving. If you're using a set of linoleum tools, make sure you have an extra set of blades.

2. Transfer the design to the wood or linoleum block.

3. Lock the block into the bench hook.

4. To begin, use a veiner or knife to outline all the areas that you don't intend to cut away (or the areas that will hold the ink). If you are using a knife, remember to slant the cut away from the area being outlined so that this area has a base on which to stand when it is printed (photo 1). Also remember to cut both sides of

the channel if using a knife. If you're using a veiner, it will automatically put the right slant on the cut, and create both sides of a channel at once.

5. Once the design is outlined, use the carving tools to begin clearing away the negative or nonprinting areas of the design. There are many ways to do this, and you'll develop your own preferred style of working. Always aim the tool away from an area that you want to leave standing so that you don't accidentally cut it away (photo 2). Follow the general rhythm and shape of the design when clearing areas

(photo 3). It isn't necessary to cut any deeper than approximately ⅛ inch (3 mm), unless you're clearing a relatively large area and don't want tool marks to show. In that case, cut as deep as you need to, taking proofs to check whether or not you are cutting deep enough.

6. Use various-sized veiners and gouges to add texture to the design. You can also use nontraditional tools such as rasps and nails that can be pounded into the block to make marks (photo 4). (If you're using a linoleum block that seems brittle and hard to carve, put it in the sun for a few minutes to soften it.)

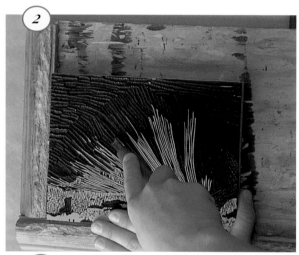

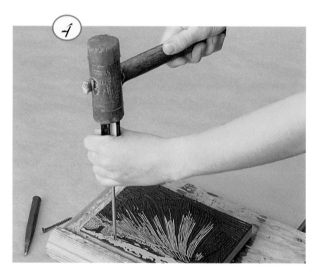

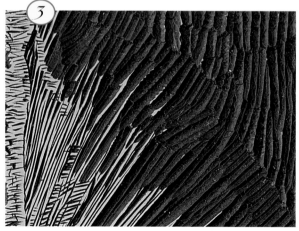

7. Ink the block with the brayer, and place the printing paper on top of it. Then add scrap paper to protect it while you burnish it with even strokes. To check each section, hold the paper in place with one hand, and carefully lift one corner at a time to check the definition of the print.

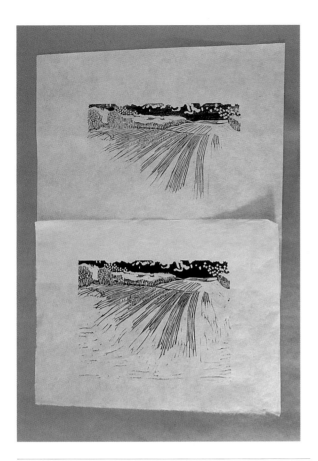

The top print has been printed so that tool marks don't show. In the bottom print, the burnisher has been used to pick up some tool marks to add textural interest.

■ To add visual contrast to a simple positive print, try printing an uncut block of the same size inked up with a background color first. When that ink is dry, print the carved block over it.

■ Along the same lines, you can print what is known as a rainbow roll underneath your print. To make a rainbow roll, you'll need two or three colors of ink, and a brayer that is at least as wide as the shorter dimension of the block. Evenly space blobs of ink side by side with space between them to fit within the width of the brayer. Roll the brayer over all the colors at once to spread and mix them. When the mix has an even gradation of colors, like a rainbow, roll the brayer on the uncut block. Print the paper with this block first, and let it dry. Then print the carved block over the rainbow background.

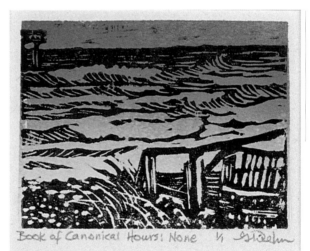

Gwen Diehn, *Book of Canonical Hours*, Block print with rainbow roll, 1997

19th-Century Japanese Woodcuts

Imagine unpacking a shipping crate and finding cups and saucers wrapped, not in old newspapers, but in astonishingly beautiful woodcut prints, completely different from any prints you had seen before. This was the experience of many Europeans at the end of the 19th century. The prints were a popular art form in Japan, and were so commonplace and plentiful there that many people used them as packing material in the same way that we use the Sunday comics.

Japanese woodcut printing had an early history similar to relief printing in Europe. Printmaking was not considered an art form but, rather, a medium for reproduction. Most prints were made to spread religious ideas. But around 1660, a group of Japanese artists revolted against tradition and began producing prints that dealt with the transience of everyday life. These prints were called ukiyo-e, meaning "pictures of the transient world of everyday life" or "the pageant of passing life." They were different from earlier prints not only in subject matter but also in point of view, composition, treatment of space, interest in flat areas of color, and use of pattern. There were many fine ukiyo-e artists, such as Hiroshige and Hokusai, and their works are still considered masterpieces today.

Ukiyo-e prints had great popular appeal. Their subject matter ranged from famous warriors and actors to domestic scenes and landscapes, and all

Left: Kitagawa Utamaro (1753-1806), Untitled, Date unknown, 15⅛ x 9⅞ inches (38.4 x 25.1 cm); Japanese color woodcut, restrike. Courtesy of the collection of Lewis and Porge Buck.

Next page: Kitagawa Utamaro (1753-1806), Untitled, Date unknown, 12½ x 8½ (30.5 x 21.6 cm), Japanese color woodcut, restrike. Courtesy of the collection of Lewis and Porge Buck.

with a focus on the ephemeral nature of everyday life. Because of the great demand for these prints, production was streamlined. Generally, the master artist painted the design with brush and ink on a thin piece of paper. From there, artisans pasted the design down on a woodblock and carved away the surface of the block from all areas except the lines painted by the artist. Prints were taken from this key block, and they were marked up to show different color areas. Other artisans glued these marked prints to blocks and carved away all but the areas needed to print the colors. Once all the blocks were carved, they were quickly printed with different colors of ink mixed with rice paste. The entire process was done very quickly, much like today's newspaper production.

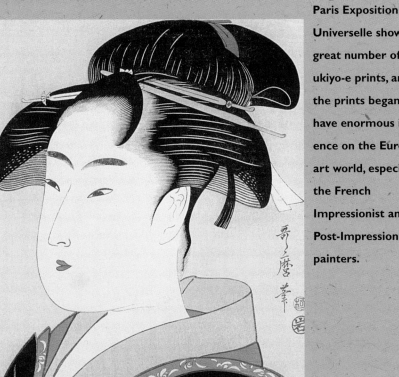

It took at least a century for ukiyo-e prints to reach the western world and two centuries before they were widely known in Europe. Many people no doubt first saw them in packages of china imported from Japan. A few appreciated the refinement and delicacy of the prints and began to collect them. In 1867, the Paris Exposition Universelle showed a great number of ukiyo-e prints, and the prints began to have enormous influence on the European art world, especially the French Impressionist and Post-Impressionist painters.

Multiple Block Print

A MULTIPLE BLOCK PRINT INTRODUCES the possibility of layers of color and texture created by carving and printing several blocks of the same size in exact alignment or registration. Once the blocks for this process are carved, infinite possibilities exist for inking them with different colors, while the components of the design remain the same. This method requires careful planning in the design, cutting, and final registration or alignment of the blocks.

MATERIALS AND TOOLS

Several blocks cut to the same size. (Poplar, white or yellow pine, or basswood are good choices if you're using wood. For very large blocks, you can use reasonably priced pine shelving that is made up of small pieces of wood glued together.)

Sanding block

Small amount of dark water-based ink and glycerin, photocopy paper or white bristol drawing paper cut to the same size as the wood or linoleum blocks, and marker for transferring the design (if using key block method below)

Wood- or linoleum-carving tools

Sharpening stones, oil, and rags (if using wood-carving tools)

Bench hook

Wood putty for block repair

Baren or other burnishing tool

Scrap paper and graphite pencil for proofing

Oil- or water-based inks

Vegetable oil and rags for cleanup (if using oil-based ink)

Ink slab or tray

Putty knife

Brayer

Printing paper

PROCESS

There are several ways of creating a color separation to use for a multiple block print. For each of these methods, you'll need blocks cut exactly the same size as your design. If you're using woodblocks, sand them to remove any milling marks. Choose from among the following methods, depending on the needs of your design:

KEY BLOCK METHOD

The most straightforward method of creating a color separation is that of first carving a key block—a block that carries the main lines of the design. Other carved blocks are used to print sections of color over or under this design.

A. To begin making the color separation, draw the key block design, and transfer it to the first block (key block) by a method of your choice. Sharpen the carving tools, and carve the key block to define the main lines and

areas of the image. Ink the block with a combination of water-based ink and a few drops of glycerin to retard the drying of the ink. Quickly pull a proof (or trial print) on copier paper or drawing paper that is cut to the same size as the block. If the proof is complete, immediately place it ink-side down on the second block. Burnish the proof to transfer the ink to the new block (photo 1). Peel the proof away. The design is now perfectly placed on the second block, in reverse and ready for carving (photo 2).

B. Study the design, and decide where you want to place the major areas of color. Choose three or four colors that you want to print. Use a colored marker to outline the areas of the design on the second block that you want to carry the first color. Try out your ideas on tracing paper first (photo 3). Use the carving tools to carve away all parts of the block except the areas you've defined as printing that color. Texture these areas with carving tools if you wish (photo 4).

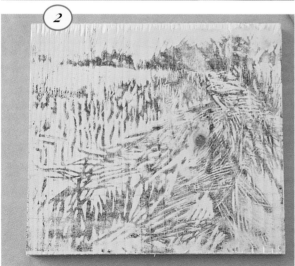

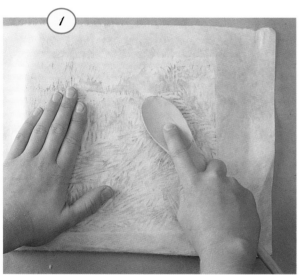

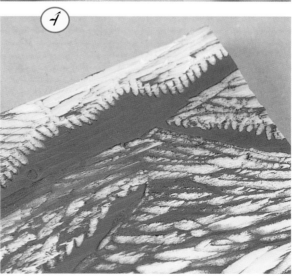

C. Make a wet transfer of the key block on the third block, and repeat step B to carve areas indicating the second color of the design. Repeat step B on a new block for each color in the design.

D. Print the series of blocks by following the instructions on pages 74 and 75 for printing multiple blocks. Colors can be overlapped to create interesting mixes. Textured areas can be printed on top of solid color areas (photo 5).

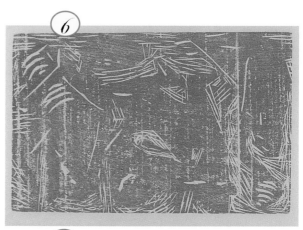

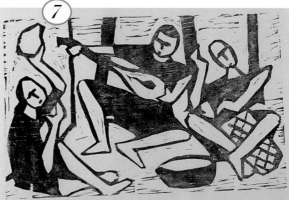

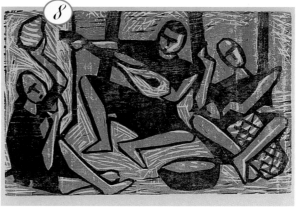

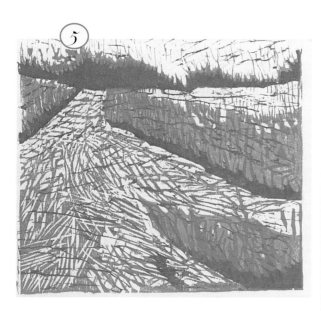

CHIAROSCURO METHOD

Another method of making color separations for a multiple block print is the chiaroscuro ("light-dark") method. With this method, a design is separated into light, medium, and dark areas.

A. Begin by transferring the design to the first block with a method of your choice (see pages 51-55). Carve away *only* those areas that should be lightest in the finished print (photo 6). (The white paper areas that show through will end up being the lightest portion of the print.)

B. Then transfer the design to the second block, and this time carve away all except the darkest parts of the design (photo 7). (The

darkest parts might include shadows, a few outlined areas, and some textures, but not complete outlines of the design.)

C. To print the design, see the instructions on pages 74 and 75 for printing multiple blocks. Ink the first block with a medium value of ink and print it on light or white paper. The resulting print separates out the very lightest areas (the paper) from a medium-toned background (the ink). Print the second block, which adds a darker value of ink, on top of the first print (photo 8). If there is a third block, ink it with an even darker value and print it on top of the other layers.

FLAT COLOR METHOD

This third method works well for designs that don't depend on outlines or a range of values but are defined by flat areas of color. Simple watercolor paintings and sketches are a good source of design ideas for this technique (photo 9).

A. Enlarge the design, sketch, or painting on a copy machine if needed. Lay a piece of tracing paper on top of the original or the photocopy, and use a straight edge or board to draw a box or rectangle around the entire image to indicate the boundary of the print that you want to make (photo 10). This boundary determines

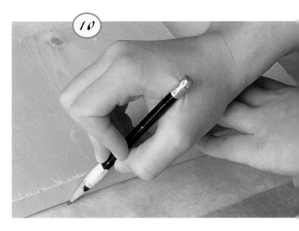

the size and shape of the block. Cut the printing blocks to this size.

B. Choose three to four colors of ink ranging from light to dark that correlate with the flat areas of color in the design (see pages 18 and 19 for assistance in making a color separation). Trace around the areas that are filled by each main color, using a different piece of tracing paper for each color. Indicate the color to be printed on each sheet.

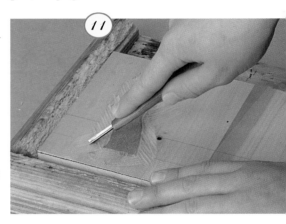

Transfer the tracings to prepared blocks, using an appropriate transfer technique (see pages 51-55).

C. Carve away the nonprinting area from each block, and add textures to the areas where you want them (photo 11).

D. When all the blocks are carved, brush them off to remove all wood or linoleum chips. Make repairs to them with wood putty if needed. Store the blocks flat with pieces of cardboard between them.

E. Print the series of blocks by following the instructions below for registration.

Printing Multiple Blocks

For any multiple block printing, it is essential to have a system of registration so that each block prints in the correct place on the paper relative to the prints from the other blocks. The simple registration system described here works well, provided all of the blocks are the same size and are completely filled by the design. If there is a border left around the design on any block, it must be the same on all the other blocks.

MATERIALS AND TOOLS

Two pieces of scrap wood, approximately 2 x 12 inches (5 x 30 cm) and the same thickness as the printing blocks

Masking tape or C-clamps

Tracing paper

Two pushpins (optional)

Printing paper

1. Place the two pieces of scrap wood together at a right angle to form a registration frame. Use masking tape to hold the wood in place on the work surface, or clamp them in position along one corner of a tabletop with C-clamps (photo 12).

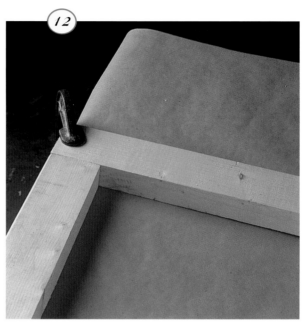

2. Place an uninked block into the registration frame. To find the correct placement for the sheet of printing paper, lay a sheet of tracing paper the same size as the printing paper over the block and frame. Center the block underneath the paper. (This placement will indicate where the print should be positioned on the paper.) Draw pencil lines where the side and top edges of the tracing paper touch the registration frame. These will be the guidelines for placing each sheet of paper every time you print it (photo 13, next page).

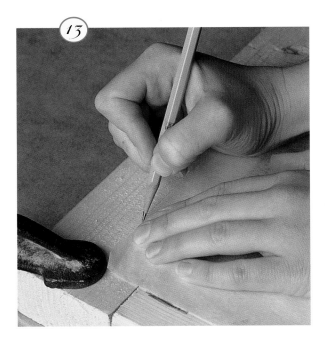

4. When printing is complete (photo 15), place the prints on a flat surface to dry, or hang them on an indoor clothesline. If you are using oil-based ink, drying can take up to a couple of weeks, depending on the temperature and humidity.

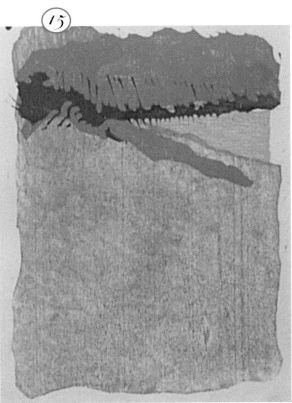

3. Remove the tracing paper, and proceed to ink and print each block in sequence on scratch paper so that you can fine-tune registration before using good paper (photo 14).

Reduction Block Technique

A reduction block is a single block that is used to achieve a multi-colored print with flawless registration. The block is progressively carved away and printed until all that remains on the block is the final stage of working. The stages are planned in advance from the working photo or drawing with overlays of tracing paper.

Reduction prints can be made from linoleum, wood, and even small rubber erasers. They require careful planning, since you can't return to an earlier stage once you've reduced the block.

MATERIALS AND TOOLS

Design

Tracing paper

Pencil

**Block that measures
exactly the same size as the design**

Wood- or linoleum-carving tools

Bench hook

Sharpening stones, oil, and rags (if using wood-carving tools)

Two pieces 8- x 12-inch (20 x 30 cm) wood the same thickness as the block, for making a registration guide

Masking tape or two C-clamps

Printing paper

Scrap paper

Oil- or water-based inks

Vegetable oil and rags (if using oil-based inks)

Brayer

Ink slab

Putty knife

Baren or other burnishing tool

PROCESS

1. Enlarge the design, if needed, so that it is the size of the finished print you plan to make. Cut the piece of linoleum or wood to exactly the same size. Trace the outline of the block on a sheet of tracing paper. (This area will form the background color.) Place a second sheet of tracing paper in alignment with the design, and indicate any sections to be cut out of the back-

ground where you'd like the paper to show through. Trace around the areas that will need to be cut from the block before the first printing (photo 1).

Place a third piece of tracing paper on top of the design. Draw around the areas that you want to carry the second color (photo 2). On a fourth piece of tracing paper, trace the areas that will carry the third color (photo 3). Continue in this manner until all the colors of the design have been included.

2. Plan the colors of the print during the planning of the design and before beginning the actual carving and printing. Keep in mind that the first or background color will be printed under all subsequent colors, and that the last color you print will be on top of the other colors. It's best to start printing with the lighter colors, and print the darker colors last, since light won't overprint dark very well. It's important to consider the effects of color mixing and layering when you plan the print.

To test out how colors will look when over-printed, use a small scrap of wood or linoleum

as a test block for printing inks on scrap paper (photo 4). Notice that printing over wet ink gives different results from printing over dry ink, and, as you experiment with colors, make notes on how you want to print the block. For example, you may decide that you like the effect of allowing the background color to dry before printing the second color, but you might choose to print the third color over the still-wet second color.

3. Once you've selected a palette of inks, you can proceed. If the background is to be a solid block of color, the block is ready to print. If the background needs to have anything carved out of it, lay the first piece of tracing paper indicating these areas facedown on the block. Burnish the back of the tracing paper overlay by rubbing it with your hands or a burnishing tool to transfer the graphite lines. Carve out

the areas where you want the paper to show through. (These will be the uninked parts of the design.)

4. Ink up the plate with the background color, and print the complete number of sheets needed for the edition plus a few extra copies to accommodate inevitable mistakes (photo 5). (If you want 25 copies of the piece, start out by printing 30 copies.) Remember, there's no going back once you've begun this process!

5. Lay the printed sheets aside to dry while you clean the ink off the plate. (If you're using oil-based inks, and want to print over dried ink, stop here and wait a few days to allow the sheets to dry.) Next, lay the second sheet of the tracing paper facedown on the clean, dry plate, and transfer the graphite lines by burnishing. Proceed as before by carving away all but the parts of the plate that are needed to carry the second color. (The areas that you carve away will be colored with the first color that you printed.)

6. Print the second color on all sheets in the edition (see pages 74 and 75 for instructions on registration).

7. Continue to reduce and print the block as described in steps 5 and 6 until all of the colors have been printed (photo 6).

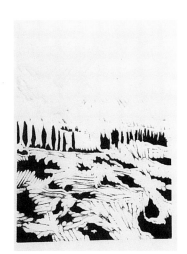

Top: Proofs taken from each stage of reduction. These proofs were not overprinted, so it is easy to see the stage represented by each.

Bottom left: The completed reduction print.

Gwen Diehn,
Near Radda,
Reduction woodcut,
12 x 8 inches
(40 x 20 cm), 1999

6

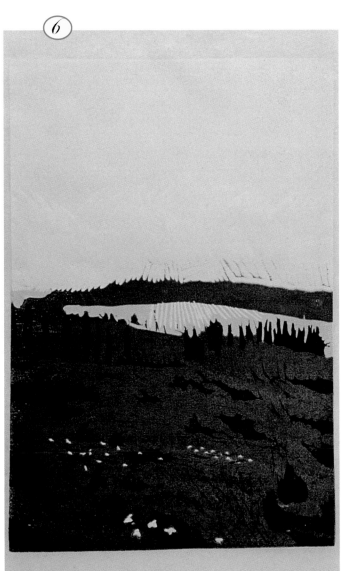

Picasso

Spanish artist Pablo Picasso (1881-1973) was responsible for an innovation in color relief printing known as the reduction block. During the 1950s, Picasso experimented with color linoleum block printing and had problems with the tight registration required by multiple block printing. He reasoned that if the same block were used for each color of the print, registration could approach perfection.

He devised a method in which he first printed a background color on each sheet of his edition (plus a few extras in case of mistakes). Then he carved all of the areas out of this block that he wanted to remain the base color and inked the block with the second color. After printing all the sheets with the second color, he cut away from the same block the areas that he wanted to remain the second color. He continued to cut away the block, each time leaving the surface area needed for the next color but removing surface area from the places that were needed to show earlier colors.

The final block contained only a small amount of its original surface, and when it was inked and printed, the edition was complete. The block had been reduced, and there could be no further prints. Picasso made a lively and colorful series of linocuts between 1958 and 1963 using his reduction technique.

Pablo Picasso, *Portrait of a Young Girl,*
after Cranach the Younger, II,
(Portrait de jeune fille, d'apres
Cranach Le Jeune, II). 1958
Linoleum cut, printed in color,
composition: 25$^{11}/_{16}$ x 21$^{5}/_{16}$ in.
(65.3 x 54.1 cm)
The Museum of Modern Art, New York. Gift of
Mr. and Mrs. Daniel Saidenberg. (Photograph
©2000/The Museum of Modern Art, New York)

Sawn Block

The sawn block method of making a relief print offers many opportunities for experimentation. In this method, the block is sawn into interlocking sections like a jigsaw puzzle. (These sections can be carved like any other block to create textures and images.) Each section is inked with separate colors, then reassembled and printed at one time. Sawn block prints have distinctive thin lines between the printed sections that are a part of the design.

MATERIALS AND TOOLS

Design that can be cut into sections

¼-inch-thick (6 mm) wood (thin poplar as well as birch plywood are good choices) cut to a size that will accommodate the design

Sanding block

Materials for transferring design to block (see pages 51-55)

Jigsaw (The best choice is a table model power jigsaw, although an electric band saw will also work; or use a hand jigsaw and a table vise to hold the wood in place.)

Wood-carving tools

Sharpening stones, oil, and rag

Sandpaper

Ink slab

Oil- and water-based inks

Vegetable oil and rags for cleanup (if using oil-based inks)

Brayer for each color of ink (or clean one brayer between uses)

Printing paper

Scrap paper

Baren or wooden spoon for burnishing

PROCESS

1. Transfer the design to the woodblock using a photocopy and lacquer thinner or carbon paper (see pages 51-55).

2. Sand the block to remove milling marks.

3. Decide where to saw the block. Use a marker to draw the dividing lines between the sections that you plan to cut apart. Keep the sections relatively large and simple with gentle curves, so that they can be cut apart with the jigsaw.

4. If you've never used a jigsaw before, practice cutting on scraps of wood of the same kind as your block. When cutting with a power jigsaw or band saw, go very slowly, and never force the saw to curve too quickly or too sharply. Back the saw off if it seems to be straining, and then proceed more slowly into the cut. Keep your hands well away from the

blade, and wear safety glasses. When you feel comfortable using the saw, cut the block into sections (photo 1).

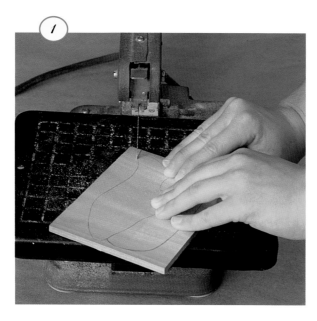

5. After the block is cut apart, sand the edges of each section, front and back. Sand just enough to get rid of rough spots without changing the shape of the piece (photo 2).

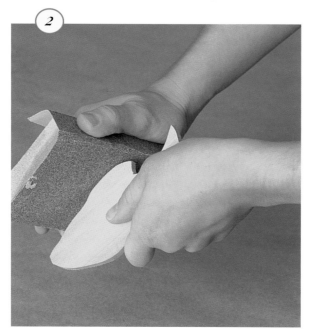

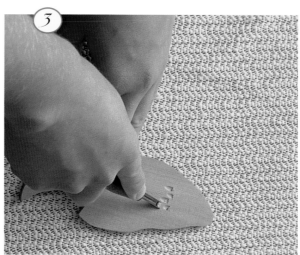

6. Sharpen the carving tools, and use them to add textures or other details to the sections (photo 3).

7. Put a small amount of ink of each color on the ink slab. Separate the cut block sections, and apply ink to each. Use a different brayer for each color, or clean a single brayer between ink colors.

8. When all of the sections are inked, reassemble them (photo 4). Carefully lay a piece of printing paper over them, followed by a piece of scrap paper.

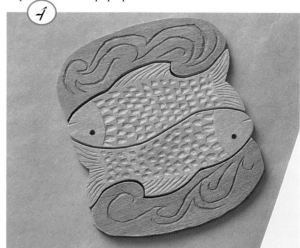

9. The trick in burnishing this block is to keep all of the sections in place so that they don't shift while you are pressing a baren or wooden spoon over the sections of the block. Lift one corner at a time to be sure that you are burnishing evenly. Be sure to rub over every section of the plate, moving your hand around to hold pieces in place (photo 5). After you've burnished, remove the papers, and place the print on a flat surface to dry (photo 6).

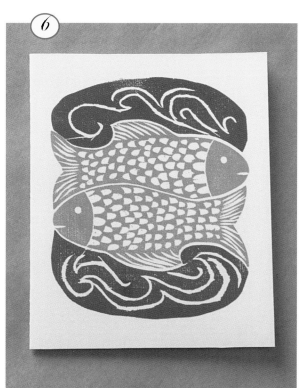

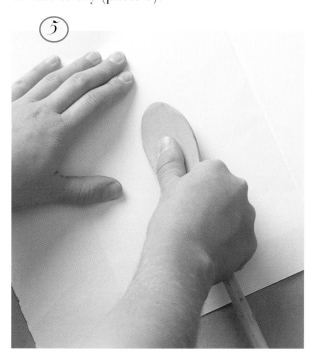

Gauguin and Munch

During the 1860s, French painter Paul Gauguin (1848-1903) was introduced to Japanese ukiyo-e prints. He began to make woodcuts in which he worked directly on the block without first drawing a design. He originally conceived his ideas in black and white, but began experimenting with color and printing his blocks slightly off-register to lend a vibrating effect to the print. He exploited the grain of the wood as well as the marks left by woodcut tools as they cleared out areas of the block.

Gauguin's innovative methods influenced the Norwegian painter and printmaker Edvard Munch (1863-1944). Munch saw the grain of the wood as so important to his compositions that he sometimes sawed his blocks into pieces like a jigsaw puzzle, often turning them to change the direction of the grain. He then did further carving on the cut pieces of wood. He inked each piece of wood in a separate color, then reassembled the inked block for printing with a single rubbing or pass through the press. The white saw lines between the sections of the print become a part of the composition.

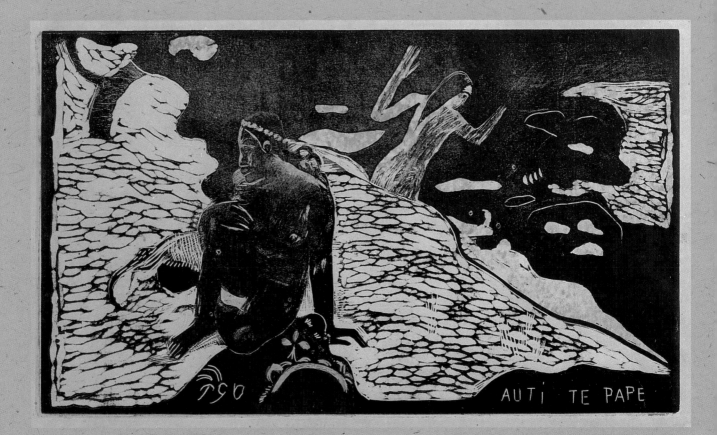

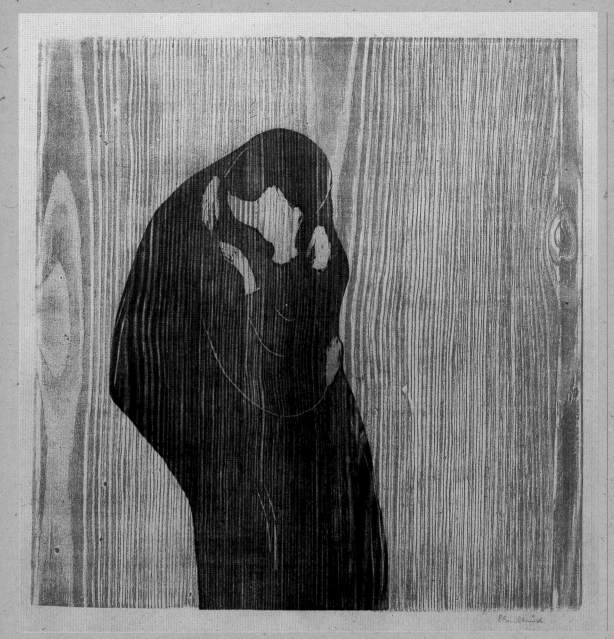

The German Expressionists of the early 20th century also adopted relief printing as a signature medium. For artists such as Käthe Kollwitz (1867-1945) and Ernst Ludwig Kirchner (1880-1938), the unrefined, immediate images made possible by direct carving of a block suited the raw emotions they sought to express. Some of the German Expressionists used bold, eye-catching woodcuts as cover designs for the journals they published, as well as for posters, letterheads, and gift prints for financial supporters.

Collagraph

A collagraph is a print made from a block or plate that has been built up by gluing objects to it in a process similar to collage. Collagraphic plates can be inked and printed in several ways, including as relief prints. The term was first applied to these prints in 1957 by Glen Alps, a professor of art at the University of Washington. When Alps and his students were experimenting by printing with found objects, they began to cut apart the resulting prints and reassemble them. During this process, they decided to reassemble them directly on the plate and glue them into place.

This technique was also developed by artists in the 1950s such as Clare Romano and John Ross, who glued cardboard shapes to a backing from which to create relief prints. Collagraphs, sometimes called cardboard reliefs, offer many opportunities for innovative work.

MATERIALS AND TOOLS

Design (optional)

Soft, 6-B graphite pencil (optional)

Burnishing tool (optional)

Carbon paper (optional)

Scissors or mat knife

Plywood block

White craft or PVA glue

Glue brush

Acrylic varnish

Materials for building up the surface of the plate: scraps of paper, sheets of rubber, pieces of non-corrugated cardboard, adhesive tape, self-adhesive stickers, string, fabrics in a variety of textures (such as burlap, organza, lace, or corduroy), leaves or other plant materials, metal foil, plastic

Flat found objects (such as coins, washers, small gears, screening, gaskets)

Wood or linoleum carving tools (optional)

PROCESS

1. If you prefer to work from a design, draw it with a soft, 6-B graphite pencil (photo 1). Transfer it to the plywood block by burnishing the back of it, or use carbon paper.

2. Prepare to build up the plate by cutting out shapes from rubber sheets, paper, cardboard, and other materials with scissors or a mat knife. Begin arranging them on the plate to form your design (photo 2). Glue the pieces in place, keeping in mind that the plate should be built to a uniform thickness of approximately ⅛ inch (3 mm) in order to print properly. Continue to build the plate by arranging and gluing on found objects and other materials of your choice to add marks and texture (photo 3).

3. Allow the glue to dry completely. After it is dried, use woodcut or linoleum tools to carve additional marks in the plate if desired. When the plate is finished, coat it with acrylic lacquer or varnish to seal it. After it is dry, use a brayer to ink the plate, and print it like any other relief print.

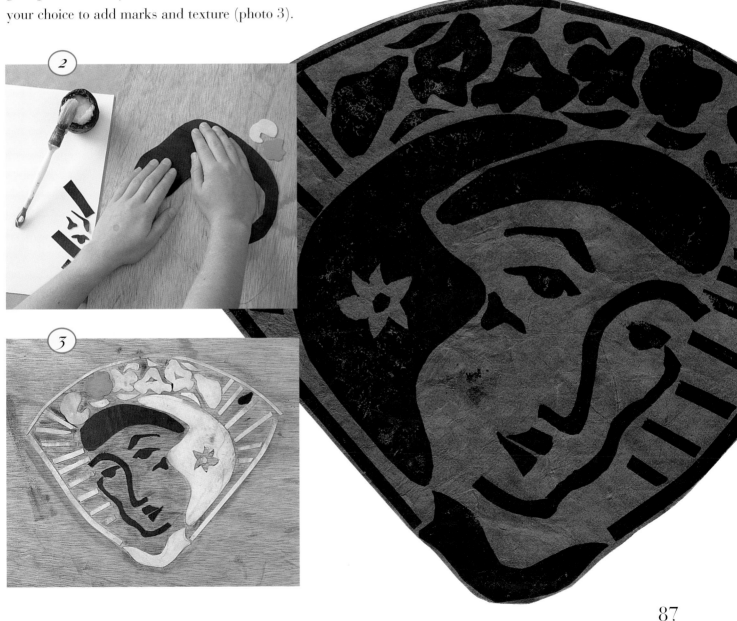

THE PROJECTS

THE FOLLOWING SECTION
CONTAINS PRINTMAKING
PROJECTS THAT INCLUDE ITEMS
SUCH AS POSTERS, STATIONARY,
CARDS, SMALL BOOKS, AND
PILLOWS. IF YOU HAVEN'T CARVED

BEFORE, EASY-TO-CARVE RUBBER
BLOCKS ARE A GREAT PLACE TO
BEGIN. IF YOU'RE ALREADY
ADEPT AT PRINTMAKING,
YOU'LL ENJOY SEEING SOME
NEW APPLICATIONS OF
SOME OLD IDEAS.

BIRTH ANNOUNCEMENT & JIGSAW PUZZLE

This birth announcement is printed from a wooden sawn block that can be used as a child's jigsaw puzzle after the pieces of the block are printed. Vary the card by printing it on different colors of paper with a variety of ink colors.

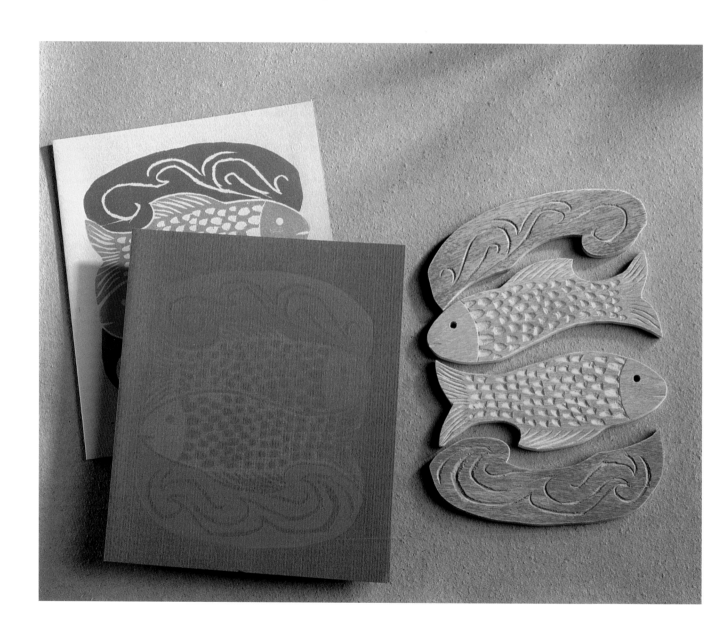

MATERIALS AND TOOLS

Sawn block (see pages 81-83)

Paper for announcements (colored charcoal paper is a good choice)

Vegetable oil

Clean rags

Paint thinner

Small paintbrush

Fine-grit sandpaper

Nontoxic clear shellac that is safe for use on toys

INSTRUCTIONS

1. Follow the instructions for the sawn block technique to carve, cut, and add ink to the blocks. Print the locked together blocks on as many pieces of paper as you need for your group of announcement cards. When you've finished, place the cards on a flat surface to dry.

2. When all printing is complete, clean the block by wiping it with vegetable oil. There will probably be some color left on the sections even after the ink is cleaned off. Rub the oily rag over the wood to even out the color.

3. Finish the cleaning by rubbing the wood with a rag on which you have put a few drops of paint thinner. Allow the block to dry overnight.

4. When the wood is completely dry, use the paintbrush to apply shellac over both sides and all the edges of each section. Lightly sand the block with fine sandpaper, and give it a second coat of shellac.

91

TEXTURED BOOK COVER

*Cover a small, handmade book with paper
printed with a distressed block design to
create a handsome object.*

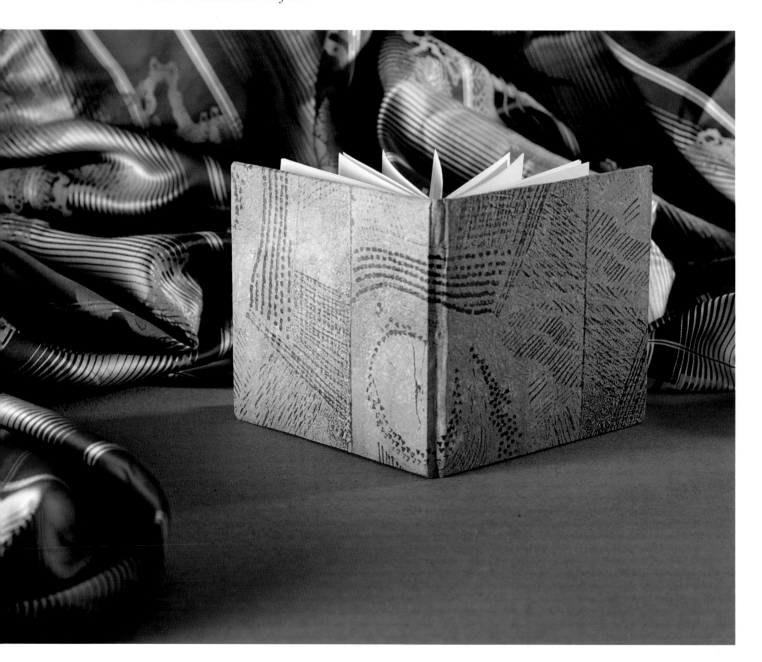

MATERIALS AND TOOLS

Distressed block print large enough to cover the outside of the book you plan to make (see pages 61-62)

7-10 sheets of computer or photocopy paper

2 pieces of chip board, Davey board (archival board), or medium-weight cardboard (not corrugated), each the size of a text page plus ⅛ inch (3mm) on all sides

Craft or mat knife

Metal straightedge

Piece of heavy paper or thin cotton cloth for hinge reinforcement

Pencil

Sobo glue or PVA (white craft) glue

Glue brush

Scrap paper

Small spoon for burnishing

Wax paper

Awl

I yard (.9 m) waxed cotton book binder's or other heavy thread

Sewing needle with wide eye

Acrylic satin or matte varnish

Soft paintbrush for varnishing

INSTRUCTIONS

1. Cut the sheets of paper to twice the width and equal to the height of the book that you plan to make. Fold each of the sheets in half and nest them inside one another to form a *signature*.

2. Use the craft or mat knife and the straightedge to cut two pieces of board for the cover that each measure the size of a text page plus ⅛ (3mm) inch on all sides.

3. Cut a hinge reinforcement out of a piece of heavy paper or thin cotton cloth that is 1 inch (2.5 cm) wide and ½ inch (1.3 cm) longer than the height of the cover boards. Position the two boards side by side with a ¼ inch (6 mm) gap between them. Apply glue to the hinge reinforcement with the glue brush and position it under the boards (fig. 1). Fold the hinge reinforcement over at the top and bottom to join the boards (fig. 2. next page)

Figure I

Figure 2

4. Place scrap paper on your work surface, and lay the cover, face down on top of it, leaving a border of around 2 inches (5 cm) of paper around it. Lay the joined pieces of cover board on the print, and trace around them with a pencil. Remove them, and draw a 1 inch (2.5 cm) wide margin at each outer edge of the boards to form glue tabs. Use a mat knife to cut along all tab lines as shown (fig. 3).

Figure 3

5. Brush glue on the entire back surface of the print. Quickly lay the cover boards in position on the print. Fold each glue tab over the board and burnish it thoroughly with the small spoon. Place wax paper over the print and cover board, and continue to burnish, leaving

no air bubbles or curling edges. Turn the book over, and burnish the other side (fig. 4).

Figure 4

6. Wrap the cover in wax paper, and put it under a pile of large books to press it flat while it dries.

7. While it is being pressed, you'll sew the signature together. To do this, open the pages of the signature out. Punch five holes with the awl: one in the center, one an inch from top and from bottom edges, and one between each of the first three holes (fig. 5).

Figure 5

94

8. Thread the needle, and leave it unknotted. From the outside of the signature, place the needle into the middle hole, leaving a tail 2-3 inches (5-7.5 cm) long (fig.6). Now, from the inside, push the needle out through the next hole up and back through the top hole to the inside. From the inside, put the needle into the second hole from the top. Skip the center hole, and put the needle into the second hole from the bottom so that you're inside again. Put the needle into the bottom hole and move to the outside. Put the needle into the second hole from the bottom to the inside. Put the needle into the center hole, and come out on the opposite side of the long middle stitch from the hanging tail of thread. Tie the tail to the needle end of the thread, and cut both ends off, leaving about an inch (2.5 cm) of thread.

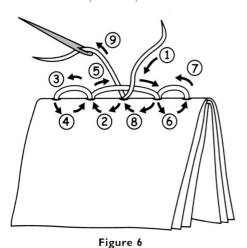

Figure 6

9. Next you'll glue the signature into the cover. To do this, lay the cover on the table with the inside facing up. Put a piece of scrap paper between the first two pages of the signature, and close the signature. Brush glue all over the top sheet of the signature.

10. Remove the scrap paper. Carefully place the glue-covered top sheet on the inside cover board, centering it so that a small edge of the cover shows on top, bottom, and outside edge (fig. 7). Lay a piece of wax paper over the page, and burnish it thoroughly.

Figure 7

11. Repeat step eight for the back cover. Slip waxed paper inside each cover to protect the signature from the glue, and press the book between heavy books.

12. When the glue is completely dry, varnish the outside of the book with acrylic varnish to protect the surface of the print.

Relief Prints and Books

From early in its history in both the east and the west, the woodcut has been associated with the book. In the days before movable type, a primitive kind of printed book called a "block book" developed. In a block book the illustration and text for each page were cut and printed from a single block. Many block books were religious in nature, such as *The Pauper's Bible, The Art of Dying,* and *The Apocalypse of St. John,* all published in the Netherlands in the mid-15th century and disseminated throughout Europe.

Block book pages consisted mainly of an illustration with a couple of lines of print that explained the picture, although there are some instances of full pages of text. When movable type was invented in the 1450s, block books gradually became obsolete, but some continued to be printed since they were simpler and less expensive to produce than books printed with type. Also, the audience for whom they were intended was largely illiterate and poor and would not have been able to read nor afford the new typeset books.

Anonymous 18th century woodcut

The invention of movable type created a new use for woodcuts as illustrations that could be locked up, inked, and printed with type on a press. The first printed book with illustrations was the *Fables* of Ulrich Boner, published in 1461 by Albrecht Pfister of Bamberg. In this early period, text and illustrations were printed separately, and the illustrations were hand colored after they were printed. Woodcuts continued to be the dominant form of book illustration until the 18th century, when copper engraving began to be used more often.

In the 18th century, inexpensive popular books called "chapbooks" were published and sold by traveling peddlers to the general public. These usually contained poems or stories, and they were illustrated with very simple woodcuts. The woodcuts were apparently drawn by self-taught artisans as they are simple and awkward in proportions, but they have an appealing directness and honesty that puts them in the same category as other naïve work.

With the invention of different processes for printing books, the relief print eventually fell out of favor. However, there have always been artists who chose the relief print for its particular look. Today, most relief print book illustrations are actually reproduced by offset lithography.

Contemporary woodcut artists who have illustrated books as well as made artists' books with relief prints include Antonio Frasconi, an Italian artist who came to the United States as a young man. Frasconi has illustrated numerous books as well as made individual prints; he has been a leader in the revitalization of the medieval art of the woodcut. In addition to his more well-known prints, Frasconi created a number of one-of-a-kind books of woodcuts for his son Pablo. Many of these are collections of carefully observed and fantastically drawn animals and insects. One of Frasconi's most whimsical projects was a book for his son in which he made prints from baked goods—animal crackers, commercially made cookies, and alphabet noodles.

Antonio Frasconi, *Boy with Cock,*
Color woodcut, 1947
Print Collection. Miriam and Ira D. Wallach
Division of Arts, Prints, and Photographs.
The New York Public Library. Astor, Lenox, and
Tilden Foundation

CHILDREN'S BOOKS

Print a small children's book with unusual plate materials. This book was printed from a combination of plates carved on floor tiles left over from a tiling job and pieces of an old drawing board.

MATERIALS AND TOOLS

Carved blocks for printing illustrations and text

Sheets of scrap paper for assembling book dummy

Colored drawing paper

Paper clip

Straightedge

Sobo or other **PVA** glue

Glue brush

Sheets from an old telephone directory or other scrap paper

Mat knife

INSTRUCTIONS

1. The first step in making any book other than a blank book is to prepare a dummy, or model, of the book. The purpose of the dummy is to let you see how the text and illustrations will be divided among the pages of the book. Make the dummy out of scrap paper cut to the same size as the pages of the book you plan to print. Fold each page down the middle to form what is called a folio so that each sheet of

Figure I

paper forms two printed pages (fig. 1). You
will print the two inside pages of each folio.
The outside pages of each folio will be glued to
the outsides pages of other folios.

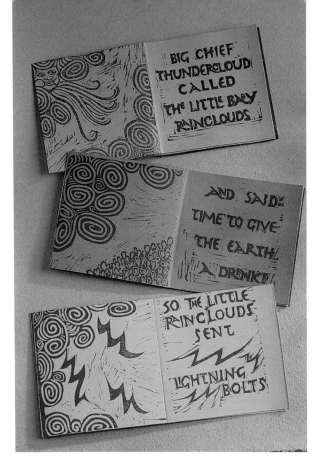

2. Draw a rough sketch to place each illustra-
tion where you want it in the dummy, and
write the text that will go on each page.

3. Stack (do not nest) all the folded folios of
the dummy, and number each inside page.

4. When you know how many folios will be
needed, you are ready to make the real book.
Cut sheets of colored drawing paper to the size
of each folio page. If you plan to make several
copies of the book, cut as many duplicates of
each page as you need. Fold each sheet in half,
then unfold them.

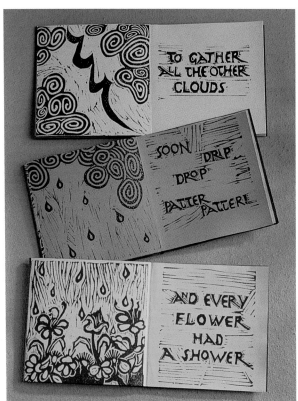

5. Ink and print each page and duplicate
pages, following the plan in your dummy.
(Remember that you will be printing the two
inside pages of each folio only.) Lay the prints
out to dry. Do not refold the folios.

6. After all the prints are dry, refold each
folio in half with the printed side on the inside.

99

7. Glue each book together in the following manner: Place sheets of scrap paper or old telephone directory inside the first and second folded folios. Brush glue all over the outside of the second page of the first folio (fig. 2).

Figure 2

8. Lay the gluey side of the first folio over the outside of the first page of the second folio, matching edges exactly (fig. 3). Place a clean piece of scrap paper over the inside of the first folio, and press or burnish the two glued pages so that they are completely glued together. Repeat steps 7 and 8 to glue all the folios together.

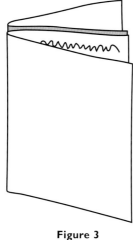

Figure 3

9. To make the cover of the book, cut a piece of paper that is the height of a folio by the width of the unfolded folio plus the thickness of the stack of folios that will form the pages of the book (fig. 4). (You must add the thickness of the stack of folios for the spine of the book.)

Figure 4

10. Place the stack of glued folios against the left margin of the inside of the cover, and score a fold line along the right edge of the stack of folios using a paper clip and a ruler (fig. 5). Then move the stack to the right edge of the inside of the cover, and score a fold line along the left edge of the stack of folios. The two lines that you have scored should be the

Figure 5

100

width of the spine of the book. Fold the cover along the two scored lines (fig. 6).

Figure 6

11. Slip scrap paper inside the first two pages of the stack of folios and brush glue all over the top outside sheet.

12. Press the gluey page against the left inside of the front cover. Fold the cover around the spine (or back) of the book, using the scored lines to help (fig. 7). Repeat steps 11 and 12 for the back cover, pressing against the right inside of the cover this time.

Figure 7

FABRIC BOOKS WITH PRINTED DESIGNS

Use a carved rubber block to print a repeating pattern on fabric-covered books that can be bought at art supply or stationery stores. The textures of the fabrics create their own magic in combination with the inks.

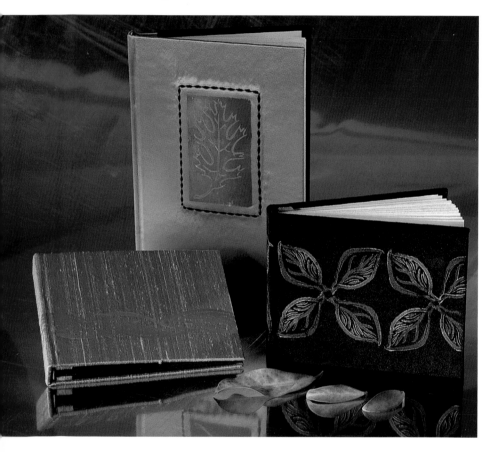

MATERIALS AND TOOLS

Fabric-covered book

Water-based fabric inks

Ink slab

Brayer

Small carved rubber or linoleum blocks

INSTRUCTIONS

1. Plan the placement of your stamped designs on the book cover. Roll one of the ink colors out with the brayer on the ink slab, and transfer a thin film of ink to one of the carved blocks.

2. Press it in place while gripping the back and sides of the block. Carefully remove it from the surface without smearing the ink. Repeat the pattern if it fits your design.

3. Allow the ink to dry completely.

Designer **Stephen A. Chapp**

HOLIDAY LUMINARIES

Decorate your doorstep, sidewalk, and windows with lighted luminaries that silhouette a festive holiday print.

MATERIALS AND TOOLS

Small paper bags that can comfortably hold a small candle

Carved linoleum block cut to fit within the parameters of the front of the bag

Light-colored ink

Dark or black ink

Ink slab

Brayer

Baren, wooden spoon, or other burnishing tool

Votive candles (one for each bag)

Sand or clay cat litter

INSTRUCTIONS

1. To create a background for the print, roll the brayer through the ink, and roll a colored background onto the flattened bags (as shown in the photo). Don't worry about making the swatch of color perfect; rough borders are ideal for this project. Allow the inked bags to dry.

2. Apply black or dark ink to the slab, roll it onto the brayer, and apply it in a thin film to the block. Place a flattened paper bag on top of the inked block so that the image is within the boundaries of the swatch of colored ink that you rolled onto the bag earlier. Burnish the back of the bag with a baren, wooden spoon, or other burnishing tool.

3. Remove the paper bag, lay it flat to dry, and repeat this process of inking and printing with as many bags as you want.

4. Allow them to dry thoroughly before opening them and adding a layer of sand or cat litter to the bottom of each bag. Place a lighted candle inside each bag.

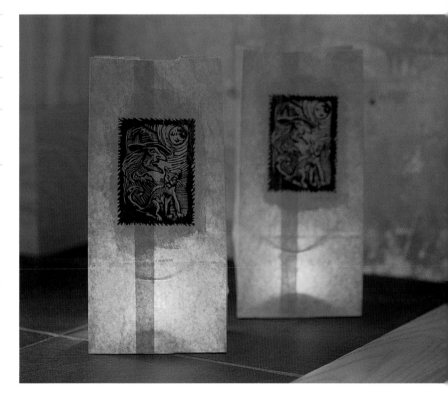

LAMPSHADE

Delight the senses of your youngest friends with a playful, animated lampshade.

MATERIALS AND TOOLS

Carved erasers or rubber blocks in several designs

Fabric or paper-covered lampshade

Rubber-stamp pads for paper-covered lampshade, or fabric stamping pads for fabric-covered lampshade

Acrylic varnish

Varnish brush

INSTRUCTIONS

1. Ink each block from a stamp pad, and use them to build a design on the shade by repeatedly printing and overlapping prints. Allow the shade to dry completely.

2. Coat the shade with clear acrylic varnish.

WRAPPING PAPER

Transform colorful sheets of tissue paper into unique gift wrapping paper by printing them with a variety of everyday objects.

MATERIALS AND TOOLS

Sheets of colored tissue paper

Old pillowcase

Found objects such as keys, nuts, and bolts

Natural materials such as leaves and flowers

Rubber-stamp pads in colors of your choice

INSTRUCTIONS

1. Fold the pillowcase in half, and place it on the work surface. Lay a sheet of colored paper flat on top of the pillowcase.

2. Ink the object by pressing it onto the rubber-stamp pad.

3. Press the object onto the paper. Make as many prints of this object as you want, to create a pattern on the paper.

4. Ink and press other objects, and add them to the sheets of paper until you've created an overall design that you like.

PERSONALIZED LABELS

Carve a self-adhesive plate, attach it to a rolling pin, and print your own labels for homemade wine, jelly, dried herbs, or sachets by rolling the image onto the paper.

MATERIALS AND TOOLS

Flexible printing plate carved with a design for your self-adhesive label

Wooden rolling pin

Text-weight, smooth paper (such as photocopier or computer paper)

Water- or oil-based ink

3- or 4-inch (7.5 or 10 cm) brayer

Ink tray

Vegetable oil, scrapers, and rags for cleanup (if using oil-based ink)

Scrap paper

INSTRUCTIONS

1. Remove the paper backing from the carved plate. Press the plate onto the rolling pin. If you've cut shapes apart, arrange them on the rolling pin so that they are in the right relationship to one another to print correctly.

2. Cut labels or cards a couple of inches wider and higher than their finished size, and lay them on a clean piece of scrap paper on your work surface.

3. Squeeze or scoop out about a teaspoon (5 mL) of ink onto the ink tray. Roll the brayer through the ink until it is charged completely with a thin, even film. Remove any chips of plate material or dust, as these will cause white marks to appear in the print.

4. Hold the rolling pin in one hand, and roll the charged brayer over the entire surface of the plate. Roll back and forth, and up and down. Examine the surface to be sure there is no line or other mark showing on the surface of the ink. If there are any lines, roll the brayer over the plate a few more times until the line disappears.

5. Roll the inked plate over the paper while pressing down on both handles of the rolling pin to insure good contact between the plate and the paper. Re-ink the plate for each label.

6. After the labels are dry, cut them to the right size.

NATURAL NOTECARDS

Celebrate the gifts of nature through notecards printed with designs of your favorite flowers, leaves, or animals. These cards were printed on textured, recycled paper with easy-to-carve linoleum blocks.

MATERIALS AND TOOLS

Linoleum block carved with a design of your choice

Sheets of textured, recycled paper (or other paper) of card stock weight

Envelopes that are slightly larger than your note-cards, so that they fit snugly inside

Pencil

Mat knife (optional)

Ruler

Water or oil-based inks in colors of your choice

Ink slab

Brayer

Baren or other burnishing tool

Scrap paper

Vegetable oil and rag for cleanup (if using oil-based inks)

INSTRUCTIONS

1. Place paper on a flat surface, and, using the ruler, lightly draw in pencil lines that outline rectangles measuring the height and twice the width of the notecard. Cut out the rectangles that you've drawn, using the mat knife and ruler, or place the ruler on top of each line and tear the paper along the edge of it to create a rough or deckled edge. Cut out or tear out as many rectangles as you plan to print for cards.

2. Use the brayer to roll out ink on the ink slab, and ink the block with an even, relatively thin film of ink.

3. Lay the inked block faceup on a clean surface. Position the piece of notecard paper on top of it, centering it upright on half of the length of the card.

4. Place a piece of clean scrap paper on top of the notecard to protect it from the burnishing tool. Press with the baren or other burnishing tool until the design is completely printed. Carefully lift the corner of the paper from time to time to check the progress of the impression. Repeat the printing process on as many rectangles of paper as you want for notecards.

5. Lay the prints out flat, or hang them from an indoor clothesline to dry. After they are completely dry, fold them in half widthwise to form notecards.

LEAF IMPRINT PILLOWS

*These oversized pillows were printed with a process that the
designer playfully calls "Buick printing."*

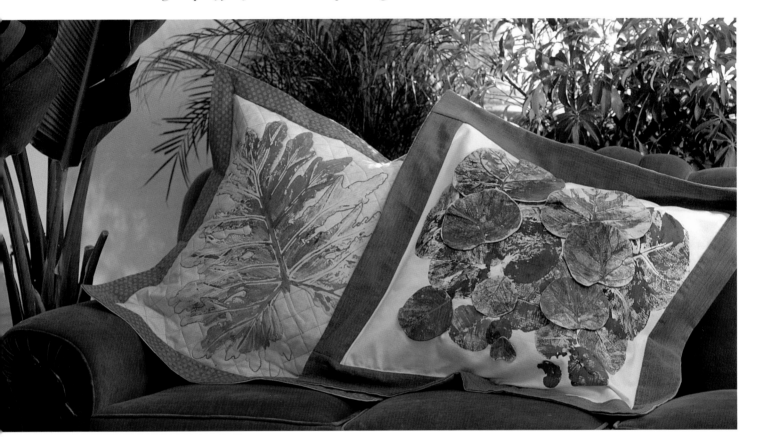

Sandra Donabed was inspired by the "otherworldy" leaves that surround her vacation home in Florida, and longed to capture their outlines and textures through fabric printing. Unfortunately, she had no printing supplies around—no inks, no blocks, and no press!

She decided that she could substitute a couple of tubes of acrylic paint for ink, but she still needed a way to create the pressure of a press.

She ended up walking the aisles of a home supply store in search of alternatives. As she was leaving the store, she saw a pick-up truck running over a small board in the parking lot, heard it make a crunching noise, and realized that she had driven a "press" to the store! She ducked back inside to buy two plywood panels and a plastic drop cloth, and the rest is history.
(Read on!)

MATERIALS AND TOOLS

Collection of large leaves

Two yards (1.8 m) of medium-weight canvas fabric

Scissors

Tubes of acrylic paint in colors of your choice

Acrylic paint extender
(to slow the drying time of the paint)

Empty egg carton

Medium-sized paintbrush

Two 24-inch-square (60 cm) plywood panels

Plastic drop cloth

Two old towels

Electrical tape

Car with inflated tires and operable reverse mode

Polyester fiberfill pillow stuffing

Sewing machine

Sewing thread

INSTRUCTIONS

1. Cut two pieces of canvas fabric that measure 2 feet (60 cm) square.

2. Assemble leaves, paint and extender, egg carton, plywood panels, scissors, drop cloth, and towels on the trunk of your car in an open garage, or on a flat cement driveway.

3. Cut the drop cloth into two 26-inch-square (65 cm) pieces. Fold and position one of the towels on top of the board, and lay a square of drop cloth on top. Pull the drop cloth around to the other side of the board until taut, and tape it into place. Repeat this process with the other board to make two padded boards.

4. Choose a set of leaves that you want to print on the fabric. Arrange them on top of one of the padded boards in a configuration that you want to print. Squirt each of the colors of paint into one of the cups in the egg container, and add a bit of paint extender (follow the instructions on the label). Use the paintbrush to coat the backs of the leaves with a thin film of the paint.

5. Quickly center the fabric square on top of the painted leaves, and place the padded side of the other board facedown on top of the fabric.

6. Jam the plywood sandwich behind one rear wheel of a car. Make sure that it is on a flat surface. Back the car very slowly over the plywood until the wheel is on the other side of the sandwich. One trip over the boards should be sufficient for printing the fabric. Remove the boards from underneath the car, disassemble the sandwich, peel up the printed fabric, and lay it on a flat surface or hang it from a clothesline to dry.

7. After the fabric dries, sew the other square piece of canvas to the printed fabric (with the print facing inside) with a ¾-inch (1.9 cm) seam, leaving enough of the seam unsewn to turn the pillow. Turn the pillow inside out, and stuff it with polyester fiberfill.

BOOK SALE POSTER

Carve a linoleum block with bold, graphic lines to make a small poster that combines an original print with computer-generated type. Simple, but very effective!

MATERIALS AND TOOLS

Sketch of image for poster

Computer-generated lettering

8½ x 11 inch (21.3 x 27.5 cm) colored or white photocopier paper

Tracing paper

Charcoal pencil

8½ x 11 inch (21.3 x 27.5 cm) sheet of unmounted linoleum

Burnishing tool such as wooden spoon or letter opener

Carving tools

Water- or oil-based ink

Ink slab

Brayer

INSTRUCTIONS

1. Make a sketch of the image that you plan to use for the poster on a sheet of 8½ x 11-inch (21.3 x 27.5 cm) paper. Size the image as you want it to appear when printed.

2. On a computer, generate type that fits around the image for the poster. Print it out, cut it apart, and tape it into place around the image to see if it works for the overall design that you're seeking.

3. Once you're satisfied with the placement of the type, tape it in place on the sheet of paper, and take it to a copy shop. If you want to create two colors of type, ask the salesperson to mask off one area and run off sheets in the first color. Then mask off the already copied letters, and run the same sheets back through to print them in the other color. You've now created the sheets on which to print the block.

4. Trace the sketch that you created in step one onto a sheet of tracing paper with a charcoal pencil. Flip the traced image over onto the piece of unmounted linoleum, and burnish the back of the paper to transfer the image.

5. Carve the image with the carving tools, adding textures and details as you go.

6. Ink the plate with the brayer, and carefully place one of the lettered sheets from the copy shop on top, matching the sides of the paper with the sides of the plate. Use the baren and your fingers to press the paper and transfer the image to the poster.

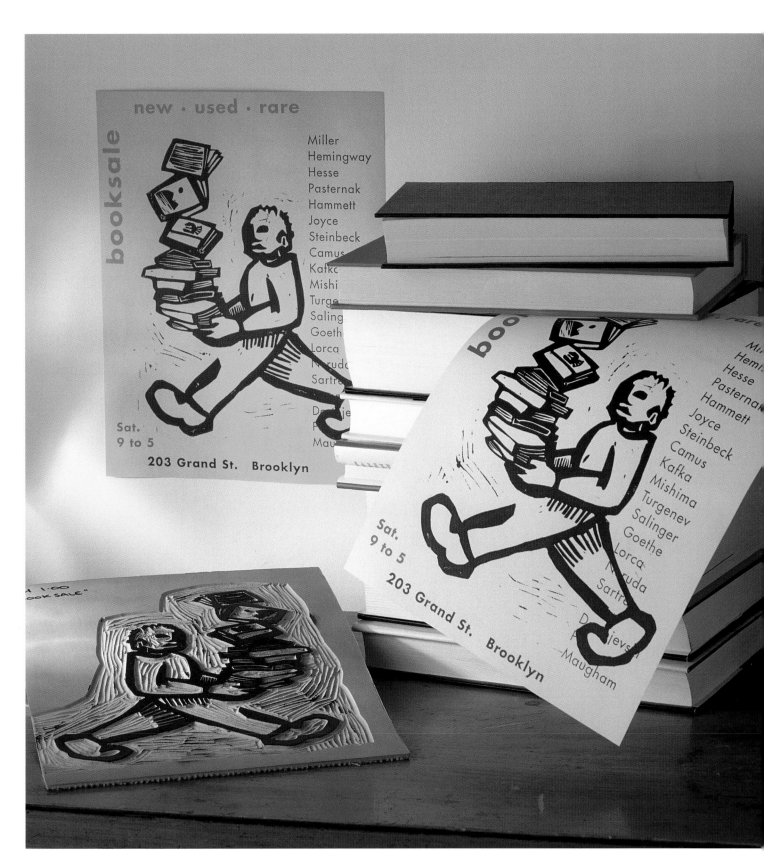

113

Posters

The bold, eye-catching, and emotional quality of a relief print makes it an ideal medium for a poster. Relief prints have been used to shout messages of protest against wars and injustice, to invite people to festivals and performances, and to celebrate holidays. During the early days of printing, relief prints were valued in part because they could be printed by hand, and thereby made larger than could be accommodated by a printing press. Images and text could be quickly carved. After the invention of movable type, type could be locked up with carved blocks and both printed at once to produce playbills, announcements, and other poster-like pieces.

Today when artists and designers want the look of a relief print, they usually carve the block and print it one time, then have the poster reproduced quickly and relatively inexpensively by offset lithography. But at least one group still hand prints their own relief prints for advertising as well as for use in their performances. Bread & Puppet, a theater company organized and directed by Peter Schumann, has been producing elaborate pageants and smaller forms of theater at the Bread & Puppet Farm in Glover, Vermont, for more than 20 years. Their themes about overcoming tyranny and oppression are played out by enormous puppets and actors on stilts. As part of their operation, Bread & Puppet produces small, inexpensive books and woodcut flyers and posters. In their studio at the farm, artists produce stark designs in woodcut that effectively express the same ideas as their performances.

Peter Schumann (Glover, Vermont),
Bread & Puppet Farm poster,
Print from pressed fiberboard,
Date unknown.
Collection of the author.

SEASONAL GREETING CARDS

By using a reduction technique, you can create a colorful holiday card without carving multiple blocks. Even though it takes practice to carve a block in this fashion, you may find that you like the challenge and results so much that you want to produce a new card for your friends each year. Rather than going into the trash, this card will become a keepsake for its recipients.

MATERIALS

Block and design

Sheets of card stock

Envelopes of a size that hold your cards snugly

INSTRUCTIONS

1. Cut pieces of card stock that measure the height and twice the width of the finished card you plan to make.

2. Use the reduction technique described on pages 76-80 to print a series of cards.

3. Lay the prints out flat. or hang them from an indoor clothesline to dry. After they are completely dry, fold them in half widthwise to form notecards.

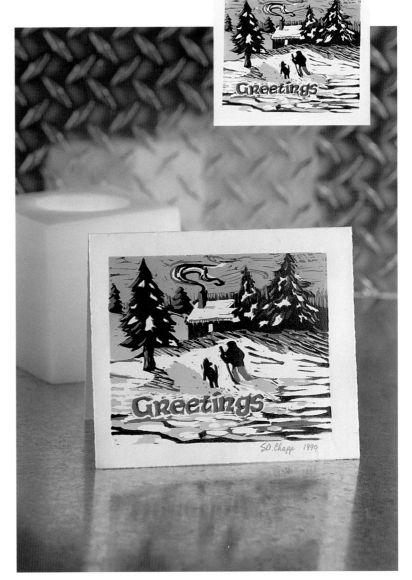

115

STAMPED ENVELOPES

These classy, individualized envelopes are printed with simple carved eraser blocks.

MATERIALS AND TOOLS

Carved rubber erasers or rubber blocks

Rubber-stamp pads in colors of your choice

Letter-size envelopes

INSTRUCTIONS

1. Ink each block on a rubber stamp pad, and stamp each envelope with a design of your choice.

2. For visual interest, vary the design by alternating blocks and printing them in different colors.

116

PAPER FAN

Create a fan with a carved design from inner tube rubber printed in bold black.

MATERIALS AND TOOLS

Printing paper

Cardboard

Wooden paint stirrer

Tassel

Mat knife

Acrylic paint

Paint brush

Ink

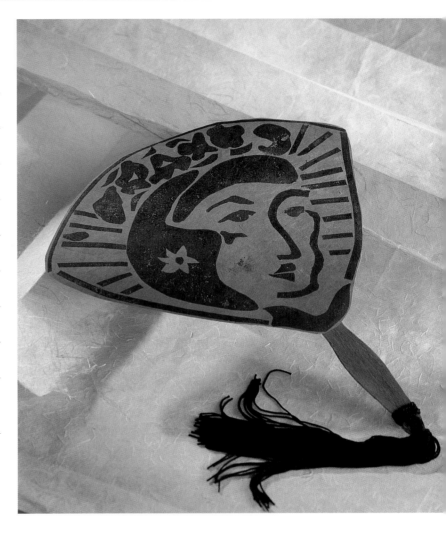

INSTRUCTIONS

1. Cut the cardboard to the shape of the fan, ¼ inch smaller than the print will be. Staple the cardboard to the wooden paint stirrer.

2. Ink and print design on paper that is large enough to cover the cardboard fan shape.

3. Cut the handle to the shape and length you would like. Stain the handle with watered-down acrylic paint.

4. Center the printed piece on top of the cardboard and glue.

5. Place another sheet of paper onto the back, glue and trim to the shape of the fan.

6. Add a tassel to the end of the handle attaching it through a hole at the end which you can create by boring an opening with a cutting blade.

117

CALENDAR

Create a keepsake calendar by designing and printing
a different work of art for each month.

MATERIALS AND TOOLS

Carved wood or linoleum blocks

12 sheets of 16 x 20 inch (40 x 50 cm) printing paper (or paper size of your choice)

Oil- or water-based inks

Brayer

Ink slab

12 large pieces of tracing paper cut the same size as the printing paper

Scrap paper

Mat knife

Straightedge

Poster frame, slightly larger than the finished size of the calendar sheets (optional)

Dry erase markers (optional)

INSTRUCTIONS

1. Decide on a layout for the calendar that includes an image and calendar numbers and lettering. Design a different print for each month of the year that fits onto the paper and leaves enough room to print the lettering and numbers. Use the multiple block printing technique described on pages 70-75 to print the image for each month in the proper position on the paper.

2. To make a guide sheet for printing the numbers and letters of each month, lay a large sheet of tracing paper on top of each print, and indicate the boundaries of the paper as well as the edges of the image on the paper. Then write in the numbers, the days of the week, and the month in the layout of your choice.

3. Use a mat knife to cut a window around the words and letters that you've written in on each sheet of tracing paper to create a template for printing these components.

4. Carve the numbers and letters from rubber sheets cut into small pieces or from rubber erasers. Carve a block with the name of each month, letters for each of the days of the week and numbers from zero to nine.

5. Roll out ink on the ink slab, or use a rubber stamp pad, and print the letters and numbers, using the templates you made earlier as a guide for placement.

6. Once the calendar is printed, place the calendar sheets in a clear acetate poster frame. Jot notes with a dry erase marker on the calendar without harming the print.

WEDDING INVITATION

Create a handsome linoleum print to serve as both a wedding invitation and as a framed work of art to give friends and members of your own wedding party.

MATERIALS AND TOOLS

Printed wedding invitations with blank front

Envelopes to fit invitations

Linoleum block carved with design that fits the front of the invitation

Black ink

Ink slab

Brayer

INSTRUCTIONS

1. Have a printing company print the text of your wedding invitation on the inside of a blank invitation.

2. To print the front of the invitations with a carved block, apply black ink to the ink slab and ink the brayer. Roll the ink neatly onto the block, and print the image on the front of the card. Repeat this process to make as many cards as you'd like.

3. Allow the prints to dry on a flat surface, or hang them on an indoor clothesline.

GALLERY

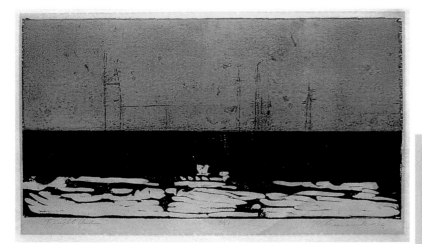

Bob Freimark (Morgan Hill, California), *Freight Yard*, 9¼ x 18 in. (23.5 x 45.7 cm), Reduction woodcut, 1956. Photo by artist.

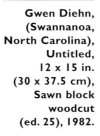

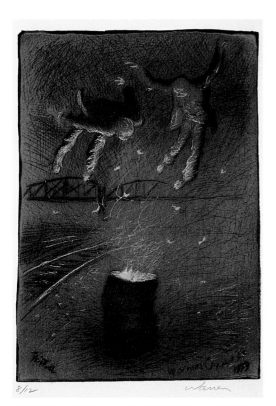

Gwen Diehn, (Swannanoa, North Carolina), Untitled, 12 x 15 in. (30 x 37.5 cm), Sawn block woodcut (ed. 25), 1982.

Warren Criswell (Benton, Arkansas), *Moths*, 7 x 5 in. (17.8 x 12.7 cm), Linoleum print, 1999.

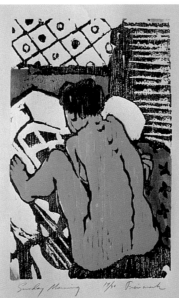

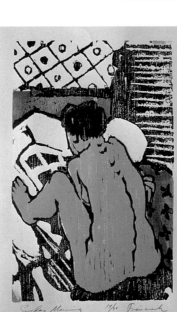

Bob Freimark (Morgan Hill, California), *Sunday Morning*, 12 x 7⅝ in. (30.5 x 20 cm), Reduction woodcut with black key-block (ed. 30), 1952. Photo by artist.

Hilary S. Lorenz (New York, New York), *Red Thesis Sequence,* 33 x 50 in. (83.82 x 127 cm), Woodcut with chine colle, 1994.

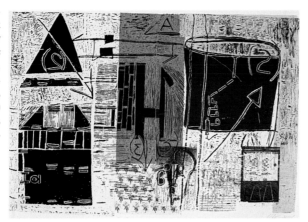

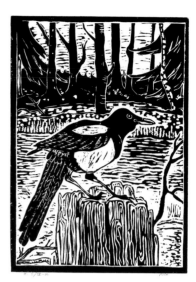

Marja-Liisa Iivonen (Katrineholm, Sweden), *Magpie,* 14 x 10 in. (35 x 25 cm), Hand printed linocut, 1993-1995.

Maureen Maki (Detroit, Michigan), *Tub,* 4 x 5 in. (10.2 x 12.7cm), Three-plate linoleum print,1999.

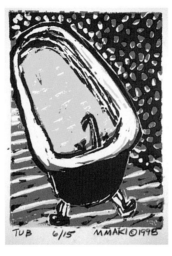

Pamela Dodds (Boston, Massachusetts), *Lovedance I,* 9 x 7 in. (22.9 x 17.8 cm), Linoleum print.

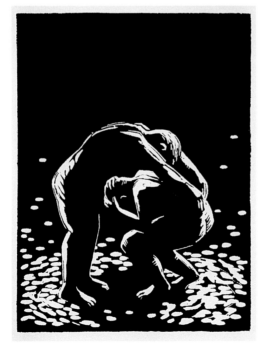

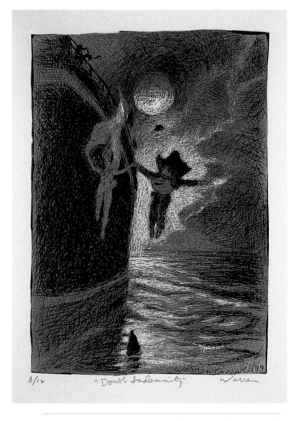

Warren Criswell (Benton, Arkansas), *Double Indemnity,* 7 x 5 in. (17.8 x 12.7 cm), Linoleum print, designs cut with needle, black printed first, white printed second,1999.

Curt Belshe (Peekskill, New York), *Mark A,* 16 x 20 in. (40.6 x 52.1 cm), Woodblock print, 1987.

Gwen Diehn (Swannanoa, North Carolina), *Under the Table,* 15 x 12 in. (37.5 x 30 cm) Woodcut print, 1982.

Jedd Haas (New Orleans, Louisiana), *Floppy Arch,* (4.75 x 7.125 cm), Relief print from flattened metal machine plates, 1999.

Andrea Rich (Santa Cruz, California), *Autumn Stream,* 16 x 20 in. (40.6 x 50.8 cm), Woodcut, 1999.

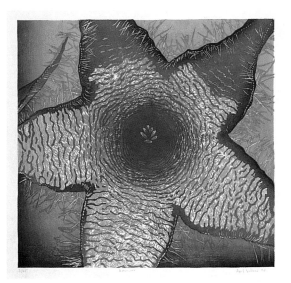

April Vollmer (New York, New York), *Attractor,* 15 x 16 in. (38.1 x 40.6 cm), Hanga woodcut, 1996.

Maria Arango (Las Vegas, Nevada), *Hija del Sol,* 8 x 10 in. (20.3 x 25.4 cm), Reduction woodcut, 1999.

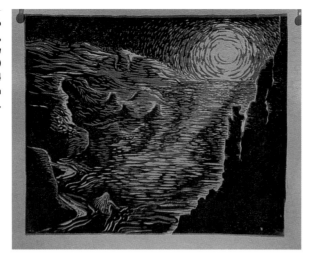

Jennifer Peterson-Paolinelli (Elgin, Illinois), *Tensions,* 18 x 20 in (45.7 x 50.8 cm), Linoleum print on copper, 1999.

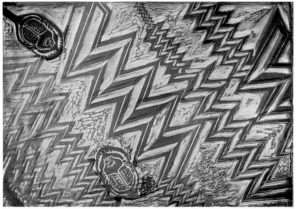

Steven A. Chapp (Easley, South Carolina), *Guarian in Turmoil,* 7 x 12 in. (17.8 x 30.5 cm), Linoleum print, 1987.

Sarah Hauser (New York, New York), *Garbanzo Bathes on Red and Orange,* 12 x 8 1/2 in. (30.5 x 21.6 cm), Japanese-style woodblock print, 1998.

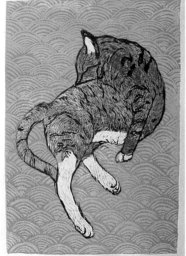

Richard Keith Steiner (Kyoto, Japan), *Eba-hon-machi,* 31 x 48 in. (78.7 x 121.9 cm), Woodblock print, 1972.

**Bob Friemark
(Morgan Hill, California),**
The Cloth Seller, **30 x 20 in.
(76.2 x 50.8 cm), Reduction
woodcut (ed. 22), 1956.**
Photo by artist.

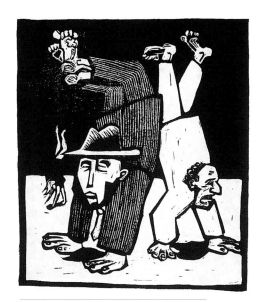

**Justin Hawkins (Brooklyn, New
York),** *Handstand*, **8 x 10 in.
(20.3 x 25.4 cm),**

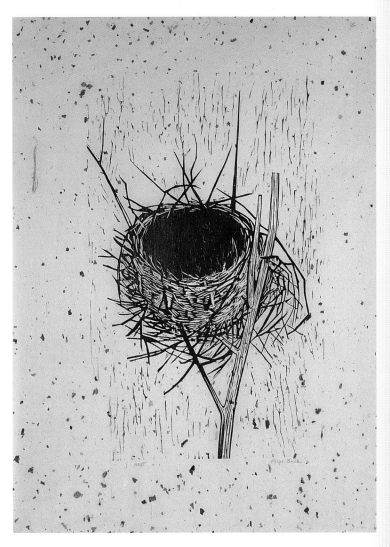

Porge Buck (Black Mountain, North Carolina), *Nest*,
**17½ x 11 in. (44.5 x 27.9 cm), 20th century.
Woodcut print.**
Courtesy of the collection of Lewis and Porge Buck.

Norma Sue McGarr (Macon, Georgia), *Peaches,* 9 x 12 in. (22.9 x 30.5 cm), Linoleum print, 1992.

Sarah Hauser (New York, New York), *Lady with Four Dogs in Central Park,* 11-1/2 x 9 in. (29.2 x 22.9 cm), Japanese-style woodblock print, 1999.

Justin Hawkins (Brooklyn, New York), *Two Men,* 12 x 12 in. (30.5 x 30.5 cm), Linoleum print, 1995.

Richard Keith Steiner (Kyoto, Japan), *Nagarangle,* 12 x 14 in. (30.5 x 35.6 cm), 1993.

Endi Poskovic (Whittier, California),
Lilliputiano, 25 x 38 in. (63.5 x 96.5
cm), Five-block multicolor woodcut.

Endi
Poskovic
(Whittier,
California),
Souffrance,
25 x 38 in.
(63.5 x 96.5
cm), Four-
block, multi-
color wood-
cut.

Melissa H. Clark (Langley, British Columbia, Canada),
Nymph II, 11¾ x 26¾ in. (29.8 x 67.9 cm), Collograph using
found objects,1993.

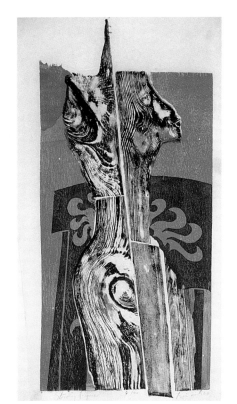

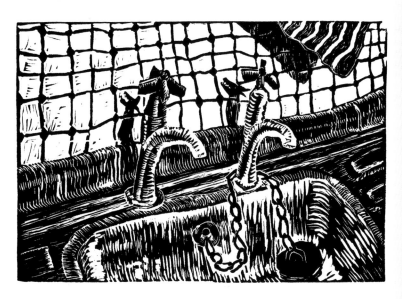

Sylvia Taylor
(Freeville, New
York),
*Kitchen Sink at
Clandeboye,*
5½ x 8 in.
(13.8 x 20 cm),
Linoleum print,
1999.

Bob Freimark (Morgan Hill, California), *Standing Figure,* 32½ x
15½ in. (82.5 x 39.4 cm), Hand printed woodcut using found
objects (ed. 20), 1960. Photo by artist.

Index